WINDOW SEAT

The Art of Digital Photography & Creative Thinking

JULIEANNE KOST

O'REILLY®

Beijing • Cambridge • Farnham • Köln • Paris • Sebastopol • Taipei • Tokyo

Acknowledgments

With special thanks to:

My husband, Daniel Brown, whose encouragement, technical support,
and ability to edit made this book light enough to pick up;

My mother and father, Judy and Gary, who set this in motion long ago;

Russell Brown, George Jardine, Luanne Cohen, Stephen Johnson, Katrin
Eismann, and Jeff Schewe, for being early pioneers and letting me play
in their sandbox;

Kim Isola, Barbara Rice, Kevin Connor, and Bryan Lamkin, for bringing
me aboard and making me want to stay;

The entire Photoshop team, whose brilliance continues to astonish me
year after year;

John Nack, for explaining what I often think I already understand;

John Paul Caponigro, Maggie Taylor, Jerry Uelsmann, Bert Monroy,
Robb Carr, and Ryszard Horowitz, for their inspiration;

Jack Davis, John Reuter, Shelly Katz, Rick Sammon, and Vern McClish,
for their enthusiasm and support;

Tony Smith, Tony Corbell, Skip Cohen, and Bob Rose, for sharing their
experience and expertise;

Steve Weiss and Edie Freedman—without their help, this book would
never have happened;

And of course, everyone I've met at events, who continually open my
eyes to what's possible.

✈

This book is dedicated to my mentor and friend, Dean Collins.

Table of Contents

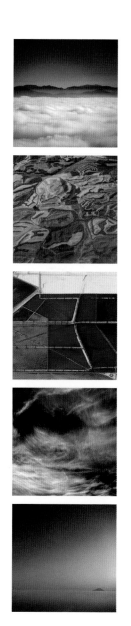

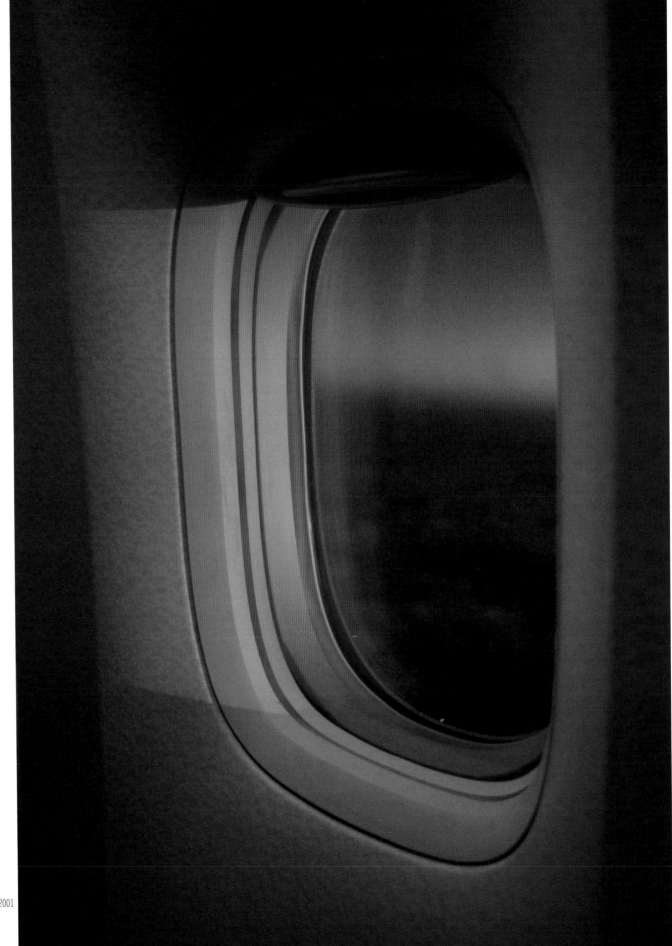

San Francisco to Tokyo, 2001

Introduction

JULIEANNE KOST is an amazing amalgamation of personalities: painter, humorist, inspirational speaker, technician, educator, photographer, and illustrator. Her incredibly popular seminars on creativity are both down-to-earth and inspirational, filled with philosophical musings, personal anecdotes, and techniques for staying awake, aware, and creatively alive. So, when the idea of publishing a book with Julieanne came up, it seemed like a great opportunity not only to present her ideas on creativity, but also to show how she "walks the talk" with one of her own creative projects. At the time, I had not yet seen any of her work. In the fall of 2004, when O'Reilly executive editor Steve Weiss first showed me Julieanne's airplane photographs, I was spellbound. I still am.

There is, in these images, a kind of purity that one rarely comes across these days. There is a stillness to them—something we don't find in the world of high tech, with its visual traffic that comes at us at an alarming rate. On long plane rides, we each enter our own mental in-flight cocoon—reading, answering email, playing solitaire, napping, staring out the window, watching a movie with two hundred other people, each of us with our own private sound system (such as it is).

Julieanne has created for herself—and through these photographs, for us—a Zen-like meditation separate from our daily lives. It is quiet and serene, yet full of the play of light and shadow. There is a quality of timelessness in these images, even as we all know that clouds are continually changing, just as the landscape beneath us changes as we fly over it.

Many of the things in our world with which we have become all too familiar are not represented here. No red or blue states. No pain, no danger, no violence. And, interestingly, no people; just air, water, earth, light, shadow.

The wonderful irony is that Julieanne was traveling for business when she shot these photographs. In the midst of an experience as inorganic as business travel, this collection of photographs came into existence by a completely organic process. They came about not because Julieanne first had the *idea* to do a whole portfolio of photographs shot out of airplane windows. Instead, she was moved to shoot one photograph, and then another, and then three thousand more over the course of five or six years. This book is the documentation of that process, from start to finish.

—*Edie Freedman, Editor*

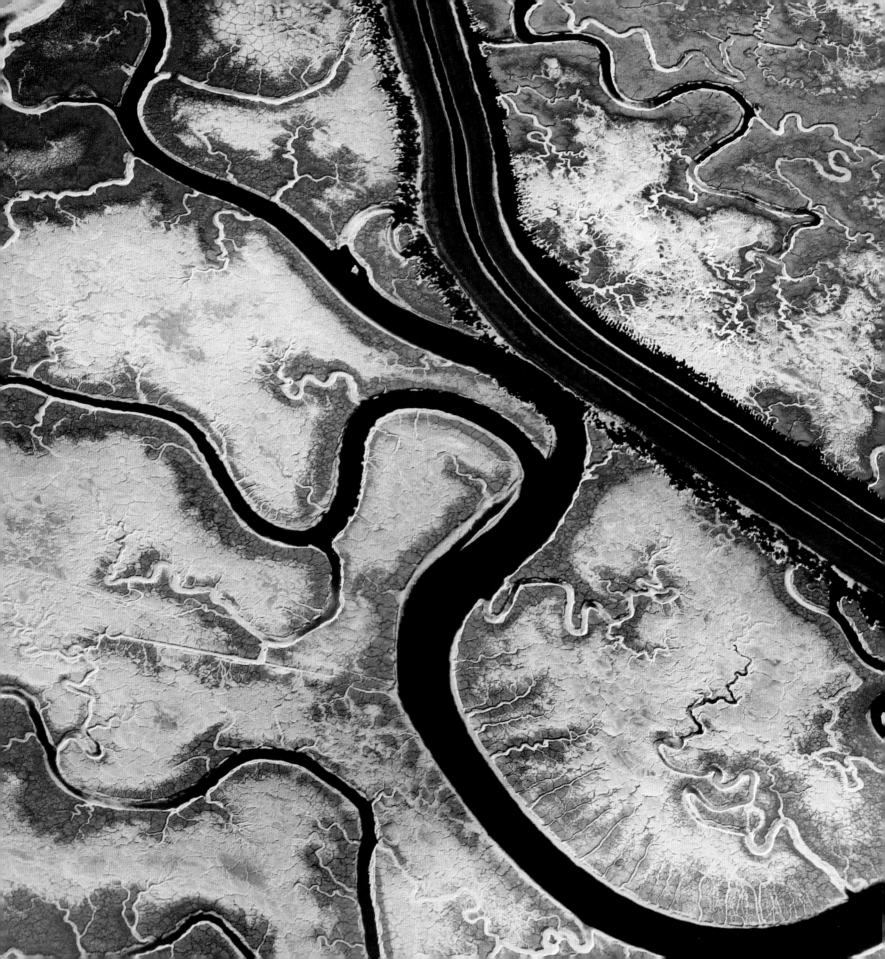

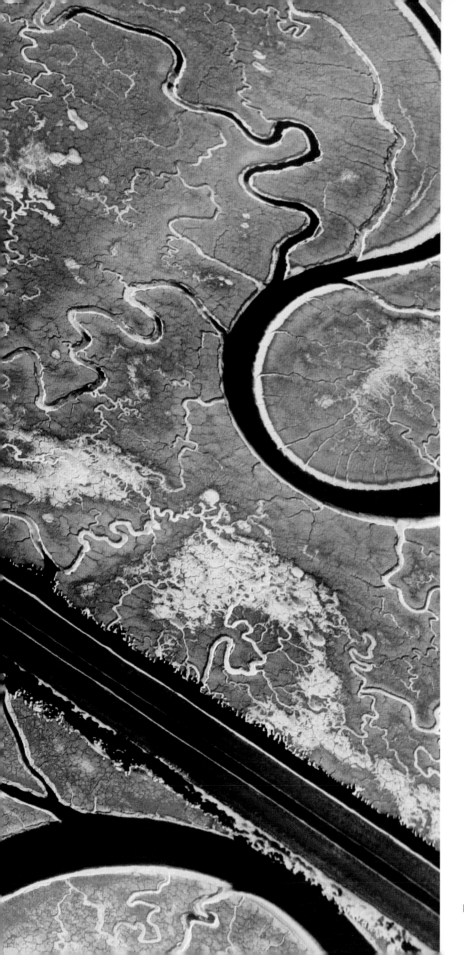

THE ART OF
CREATIVE THINKING

London to San Francisco, 2004

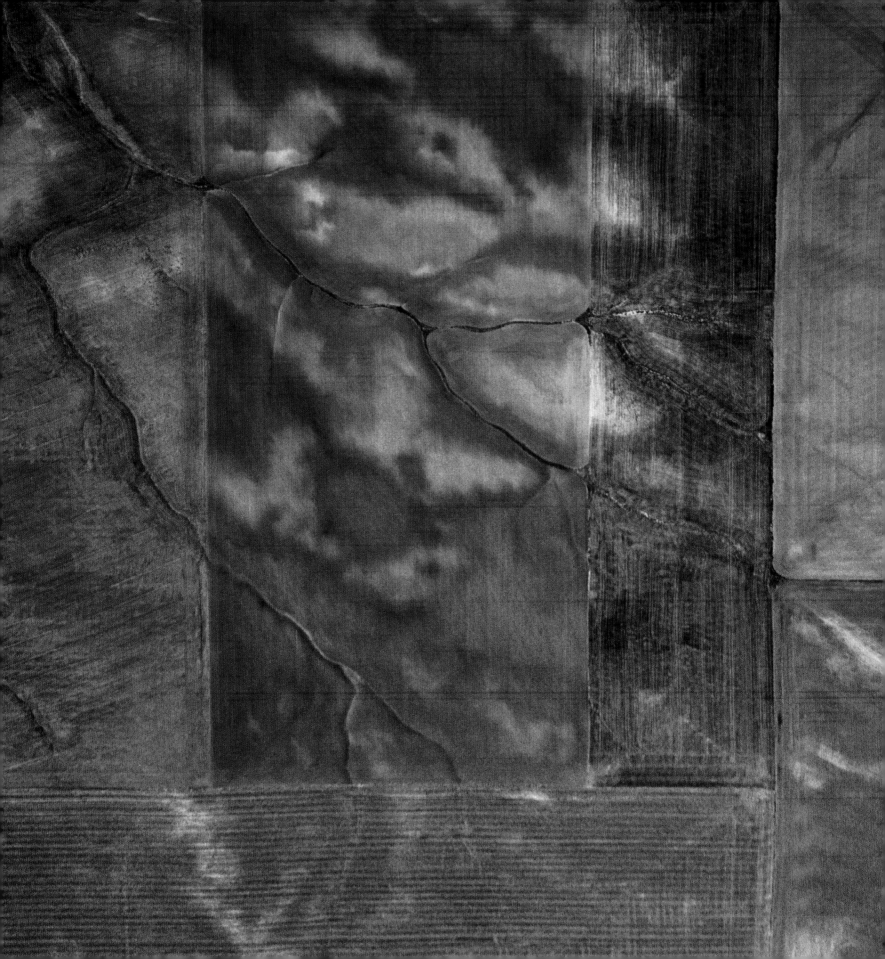

The Art of Creative Thinking

Denver to San Jose, 2003

1. Master your tools.

I grew up in a household that was both creative and technical: my mother was a painter and printmaker; my father was an engineer whose hobby was photography. It was a fantastic combination of left- and right-brain pursuits.

I watched my mom draw and paint and then turn those images into beautiful, pin-registered, silkscreened works of art. At the same time, my father explored the landscape with his black-and-white photographs and converted the laundry room into a darkroom so that he could master developing and printing. While both of them honed in on their creative goals, they also developed the technical expertise to achieve them.

The first time I remember photographing with my parents, we were in a ghost town in Nevada. My mom had always taught me to look at things in my own way, and I remember the only important thing to me as I followed them through the deserted streets was making an image that was different from theirs. I'm not sure if I accomplished it, but once I had shot, developed, and printed an image for the first time, I knew I was hooked. By the time I reached junior high, I was a photographer on the yearbook staff, and my room was covered in hundreds of photographs. I was making a collage of my life on the walls.

I think the most valuable lesson I learned from my parents was that while their approaches and the techniques they used to express to them-selves visually were different, they each had to master their respective tools from a creative as well as a technical standpoint in order to produce the images they wanted. Whether I like it or not, I realize that to achieve the results I'm after, I must master not only the camera, but also computers, software, printers, scanners—a whole host of various technologies. And, needless to say, those technologies will change as fast as weather patterns over Denver.

2. Listen to what your life is trying to tell you.

Although I loved making images, I went to college at the University of California in Davis to become a psychologist. I enjoyed helping people who were at a disadvantage and who might prosper if only they had the information that they needed to make a change. I was also a highly competitive college athlete, so I supplemented my major in psychology with a minor in sports therapy.

In retrospect, it was a great contrast: the unquantifiable study of the human mind combined with the far more literal study of biomechanics. However, an understanding of the way the body behaves and the physical stress it can take didn't prevent me from injuring myself. I broke my foot the first year, shattered my wrist the second, and fractured a rib the fourth.

After being injured three out of the four seasons of my college career, I started to wonder whether sports therapy was the right choice for me. Certainly I had been through enough

Tampa to Denver, 2001

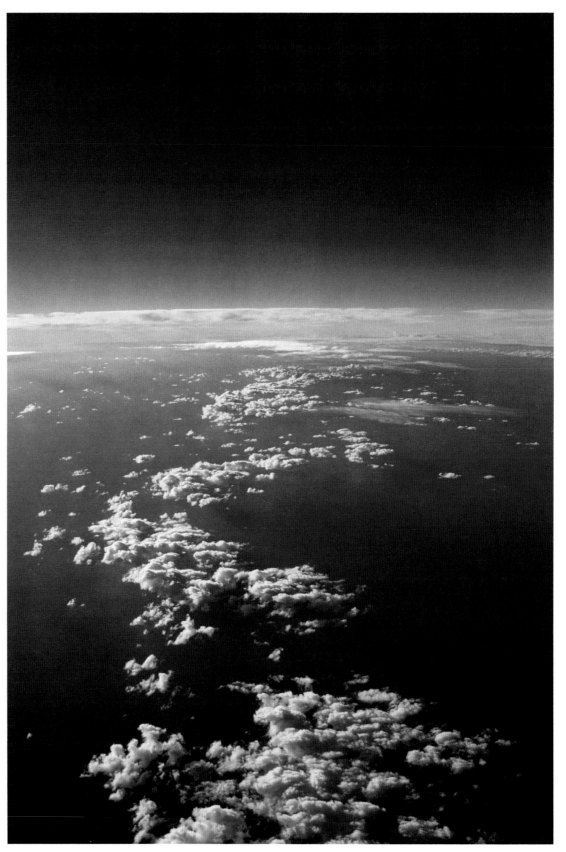

Los Angeles to Sydney, 2001

physical mending to have the necessary experience, but at the same time I was extremely disappointed at having been unable to compete. So, although I graduated with a B.S. in psychology, it was quite unclear to me what I was going to do after college.

Instead of returning to school to become a doctor of psychology, I attempted to persuade my parents to shift gears and send me to photography school instead. They didn't take the bait (and even to this day, I can't say that I blame them!). Although I could have pursued a higher degree in psychology, I wanted to find a way to help people while pursuing what I was interested in: photography.

Ultimately, I took six months off and went to work in a one-hour photo store while taking courses in photography at a local community college. In 1991, I was hired as a photo technician at a medical imaging company. There I captured images off Betacam video tapes and removed color casts, noise, and patient names from ultrasound images. At the same time, I completed an associate's degree in art at Foothill College, where I studied with Stephen Johnson, an internationally recognized photographer and pioneer in the field of digital photography.

When we met, Stephen was working closely with Adobe, giving feedback to the Photoshop development team about their product. Through that connection, I was recruited by Adobe in 1992 to serve on the technical support team for Adobe Photoshop and Adobe Premiere. When Adobe acquired Aldus in 1994, my role changed and I became a graphic designer in the technical publications group, working on the Classroom in a Book series, "Beyond the Basics" tutorials, and the user guides for Photoshop, Premiere, and Illustrator.

3. Be open to whatever comes your way.

In 1998, a twist of fate put me on a stage for the first time. Fellow Adobe employee and mentor Luanne Cohen asked me to speak in her place on "What's New in Photoshop 5.0" at the HOW Design Conference. At first, I was absolutely terrified, but I quickly realized that the people in the audience weren't really watching me—they were watching the screen. What they wanted to know was something I knew inside and out, and all I had to do was relay that information to them as clearly as possible.

As I did the demo, I saw light bulbs going on in the minds of the audience. It was so inspiring. What surprised me was that it wasn't even the most advanced feature that elicited the biggest response from the audience—instead, it was the simple tip they'd never heard before that could help them work more efficiently every single day. I realized that day that Photoshop training was what I wanted to do: it

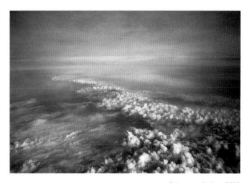

Chicago to Dallas, 2002

7

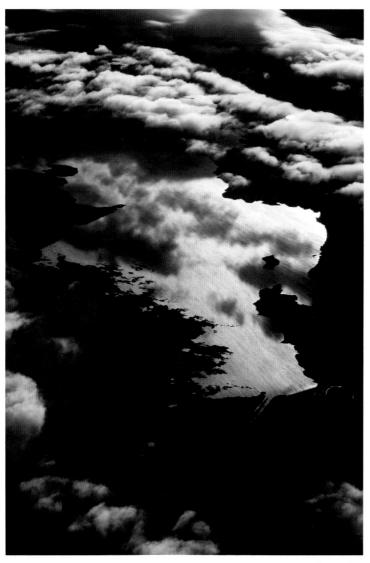

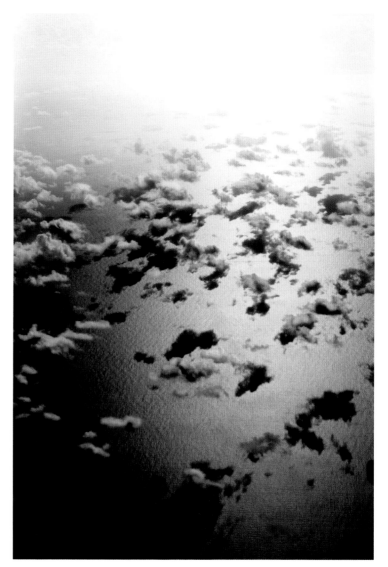

London to San Francisco, 2004

Miami to New York, 2002

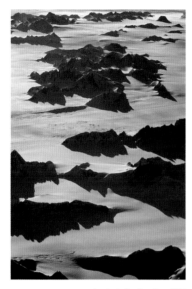

London to San Francisco, 2004

was the perfect pairing of my desire to educate people while using a tool I was passionate about, and I loved it.

With the help of Russell Brown and George Jardine, I soon became a "Photoshop Evangelist," which essentially meant that my job was to be a conduit between the engineers developing the product and the diverse group of people using it. Over time, the role has expanded to include customer education, product development, and market research for photography, design, digital imaging, and illustration.

4. Share what you know and learn from others.

The people I've been fortunate enough to meet—and it's been a diverse group, ranging from designers to photographers, fine artists to scientists—have had a profound influence on me. They constantly expand my notions about what digital imaging means and how Photoshop is used. They expose me to new ideas and ways of thinking and problem solving, ranging from how best to photograph wildlife on a glacier to capturing a criminal using an unimaginably blurry photograph. We connect because we're passionate about what we do and because we share information to help each other achieve our respective goals.

The people I see as being the most successful (personally as well as financially) tend to share everything they know. They don't fear that giving away technical information puts them at a disadvantage. In fact, because they realize that

they can't possibly know everything, this is the only way to go about their work. Their biggest assets are who they are, how they think, how they view the world around them, and how they solve problems. They prefer to talk about what the content of the image is communicating, rather than the techniques used to capture it. They realize that sharing technical information can help craft a mechanically proficient print, but having something to say with an image is something else entirely.

5. Collaborate with other creative people, especially the quiet ones.

Collaboration can be tough in a creative environment since many creative people tend to be a bit more introverted and may not press their ideas in a group. In fact, I've often witnessed firsthand how email has changed working in a creative group, since questions can be asked and answered without the pressure of a group setting. People often feel that they can be more open about their opinions via email or when instant messaging. Also, many introverts need more time to consider their responses. A group meeting may require them to respond to questions immediately, sometimes stifling their ideas and opinions. Having creative people around is a wonderful asset, so it's such a loss when an opinion isn't heard.

Sharing your work with other people is also important—especially as you're working on it. Sometimes, I just need a sounding board, someone to talk to about a piece in order to clarify the direction of the piece. I'm fairly

9

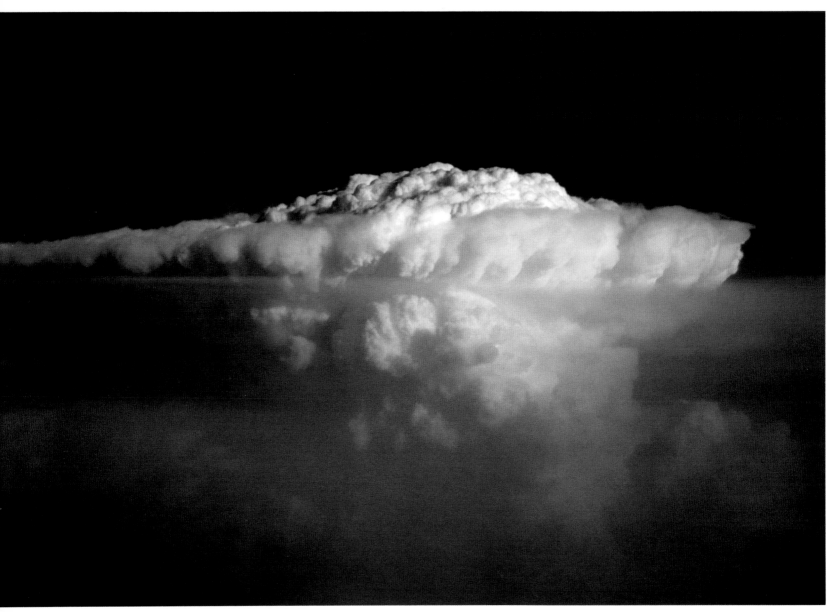

Denver to Tampa, 2002

Denver to Tampa, 2002

confident that just talking to myself would help a little, but talking to another person really brings what I'm trying to say into focus. By verbalizing a concept, it becomes that much more real and helps me to keep going on a project when I'm stuck in a rut.

6. Be flexible. Learn to negotiate.

This is one I struggle with daily. Pick your battles. Fight for the things you care about most and let the rest go with as much grace as you can muster. In short, recognize what you can and cannot affect.

We all know how wonderful we feel when everything goes well with a piece, but for every time artwork flows from me, there are at least twice as many times when it just gets stuck somewhere. It's important that I have the flexibility to put a project away for a day, a week, or a month. A piece of art is destined to become what it's meant to be in its own time, and you can't force it into being anything else prematurely.

As for negotiations, if you can't negotiate on your own behalf, you will miss out on getting all of the things you want and deserve, whether it's a bigger paycheck, additional time to work on a project, or more time off. It's worth learning how to effectively ask for what you want. This also enters into the world of "managing client expectations." Clients will want the world—they want it now, and they want it for free. Set realistic expectations and deadlines. Then, when and if you have the opportunity, you can "over-deliver."

7. Fix whatever you complain about the most.

If you can do this, it will have a profound effect on your life. Take a good look at yourself and your life and see what really bothers you. Whether it's your job, your computer, how much rent you're paying, or how long it takes you to get to work, the things that keep you up at night take your focus away from being creative. Some things can be easily remedied; others—like bad habits—are harder to change. All of the energy you expend on those things can be spent elsewhere in more creative ways. We tend to want to "do it all," but choosing what to spend time on is a huge step toward getting more out of your own creativity.

I suppose this is just another way of saying "figure out what your priorities are." What is truly important to you? Is it possible to let those other things go so that you can devote more time to what you enjoy doing? What are your short- and long-term goals? Have you ever put them down on paper? I would highly suggest that you give it a try.

Once you've settled on what's important, keep those goals close at hand so that you can refer to them as you need to throughout the day, week, or month—or until the goal is met. If necessary, break down those large, overwhelming goals into smaller, manageable, and, most importantly, *attainable* goals. Make sure that the results are quantifiable; don't make your goal something like "I will get in shape." Instead, tell yourself, "I will work out three times this week." If you don't succeed, don't give up—just try again. And when you do reach your goals, don't forget to reward yourself!

11

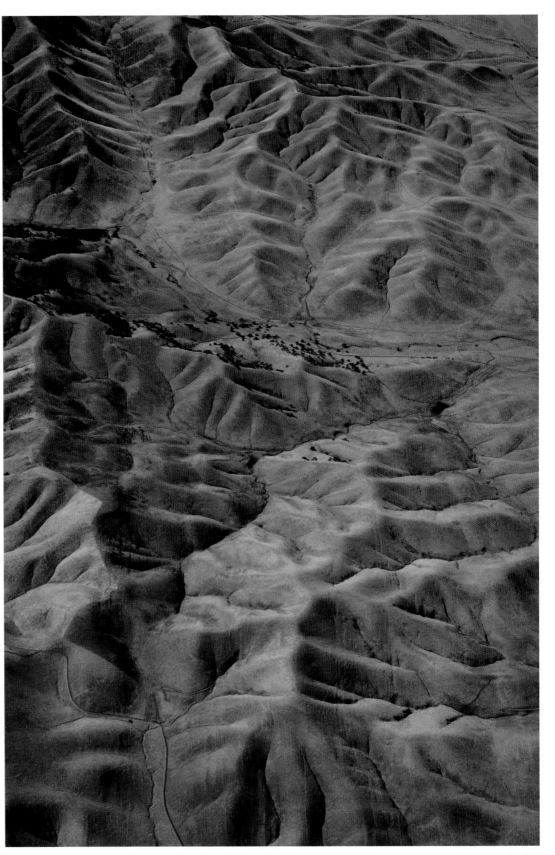

Chicago to San Jose, 2004

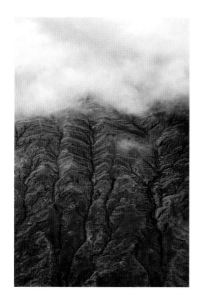

Chicago to San Jose, 2005

8. View every challenge as a possible discovery.

Ever heard the saying, "There are no problems, there are only opportunities"? This is an attitude worth cultivating, and you can make it work in your own life. My friend Tracy has taken this attitude to the next level. She says, "If opportunity doesn't knock, build a door!" Don't fight change—it's the one thing you can be sure will occur.

9. Take 15 minutes for yourself every day.

I struggle with always putting work (i.e., obligations) before creativity. I have a very difficult time allowing myself to enjoy being creative unless everything else is done. Specifically, I abstain until everything else has been checked off my list of obligations. It's as if I'm Cinderella and I have to get everything done before I go to the ball. If you have this tendency, make sure you do eventually get to the ball, even if it's just for 15 minutes.

10. Figure out what you need to do to reach your "zero point."

Your "zero point" is the point at which you can let go of everything—when you stop thinking about life, work, and the things that make up your daily routine. I can't mix creativity with daily stress. I need to unwind from work pressure, change my environment, and even do some mindless domestic tasks, such as laundry, before the creative process kicks in (or before I allow myself to focus on it).

You must find your own form of meditation. I tend to picture meditation as the practice of sitting in an uncomfortable position on the floor, but I think people meditate more than they realize. When I used to commute about an hour each day, I noticed that the stress I had been feeling at work was washed away during the commute time. It was a transition period, a kind of meditation. Now that I no longer have a commute, I like going for a long walk in the morning—this exercise serves as a meditation and keeps my body and mind active.

11. Integrate work and art; both will benefit.

Photoshop isn't just my occupation; it is also my preoccupation. In my personal work, it has become my primary creative tool—the most powerful implement in my toolbox. It is what I use to make the images I see in my head. It is the translator of my thoughts into my visions. For me, a computer isn't merely a shortcut for accomplishing what is possible with a camera and a darkroom. Instead, using a computer to create art is about exploring that which is possible in no other medium and taking advantage of its flexibility and advantages for the purpose of creative exploration.

There is a lot of crossover between my personal work and the work I do for Adobe. This suits me perfectly. I feel very fortunate that practically everything I do for my job helps me to move forward in my personal work. I like to think that the line between the two is drawn with water-based marker on wet tissue paper, my two lives blended delicately together. Not only does my professional work push me forward, but I also use what I learn from my personal projects to do a better job at work.

13

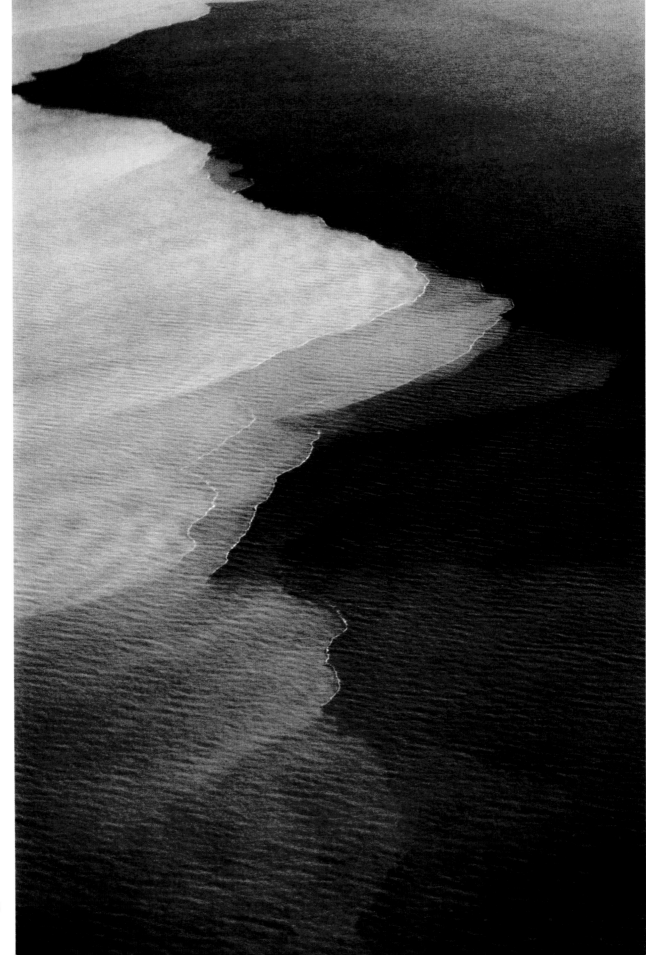

14

Vancouver to Victoria, 2005

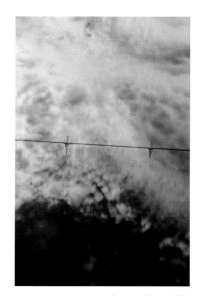

San Jose to Chicago, 2005

Being so involved with the product on a daily basis—for Adobe at work and in my own projects at home—helps me understand how, why, and where customers can use particular features. I also see the ways in which Photoshop profits them financially (saving both time and money) and gives them satisfaction with their work. Essentially, I have a symbiotic relationship with the people I speak to; they learn from me just as I learn from them.

12. Take up an interest in something you know nothing about.

I call this my "become a beginner" slogan. It flips the "learning switch" on and expands your mind in a new direction. Besides, it's fun—you don't have to know anything about it, and there's no such thing as a stupid question. I've found that as I get older, I habitually fall back on the things I already know, and I am perhaps more resistant to new experiences. The occasional class in encaustic painting, ceramics, or scuba diving keeps my brain busy and, hopefully, well exercised.

13. Look at new stuff—and at what you already know—with a fresh perspective.

Pay attention. Don't go through life in a daze. We're creatures of habit—we drive to work by the same roads every day, we eat the same foods, we tend to solve problems in the same way time after time—and it's very tough for us to break out of our molds. But if you do something different every day, you simply expand on your base of experiences.

(On the other hand, we're so overwhelmed with information—some of it significantly more useful than the rest—that learning to filter is a valuable skill to acquire as well. The camera is my filter—filtering in what I want to see in the world and filtering out what I want to ignore.)

If you really want to get a fresh perspective on things, try spending some time with a child. The children that I know aren't afraid to ask questions or say what's on their minds—for better or worse! You might be surprised by how honestly they respond to your work and how much you can benefit from their perspective.

14. Keep a journal.

The most difficult part of keeping a journal is starting the first page. It's a bit like the opening scene in the movie *Adaptation* in which Nicolas Cage's character is thinking out loud. In my case, it sounds like this: "I don't know what to write. If I did write something, I might not like it. What if it's not written well? What if I misspell something? What if my handwriting looks poor; I have never had very good penmanship. If I could just write one page…if I write one page, then I'll feel better. I'll reward myself—maybe a piece of chocolate. Yeah. If I can write one page, I'll eat a piece of chocolate. NO, not chocolate, because then I would want a second piece when I write another page. I have no self-control. If I could control myself, I'd be a better person. No, if I could control myself, then I'd be able to write." And so it goes. My advice is: just start writing, and then keep going.

I use two different sketchbooks—both without lines—and I carry them with me everywhere. One of the books is for work-related topics; the

15

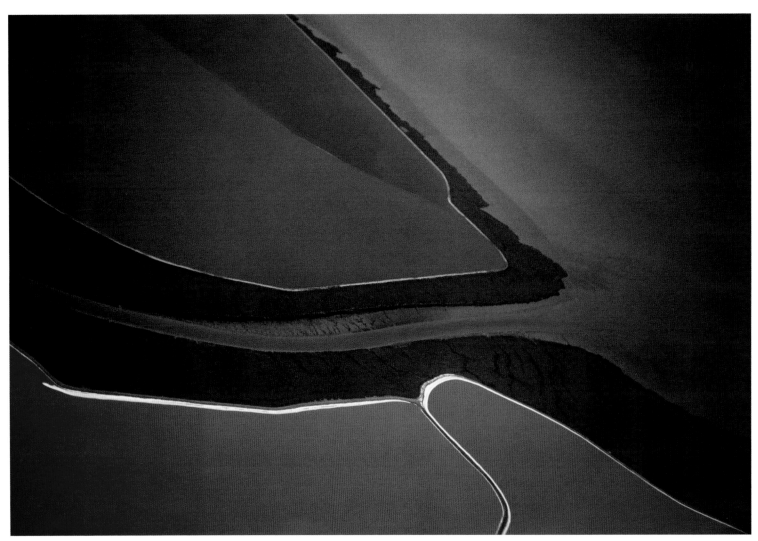

Denver to San Francisco, 2000

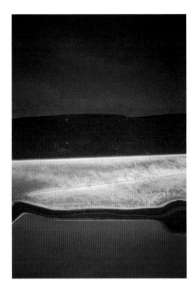

Denver to San Francisco, 2000

other is for my personal thoughts. This seems to work for me; I can create all of my to-do lists in my "work" book where I can make a mess and cross things off of my list.

The personal journal is a kind of catchall for random thoughts, sketches, diagrams, and scraps of things I come across that I want to remember. I have sections for advice and words of wisdom I encounter, movies that people recommend, websites worth surfing, and bottles of wine I've enjoyed and would buy again. Really, anything I don't think I would remember otherwise. Some entries are simply humorous, while others are things I know I need to give more priority to.

Here are some of my favorite notes from the "quotes to remember" section:

> *"Genius is the ability to edit."*
> —*Charlie Chaplin*

> *"If you don't have your camera with you, how are you going to be ready for the first shot?"*
> —*Jay Maisel*

> *"There is no conceivable law by which a man can be forced to work on any terms except those he chooses to set."*
> —*Ayn Rand,* The Fountainhead

> *"Making art is hard! Remember that when you want to quit, don't. Just stop for a while. You can begin again after stopping, but not if you quit."*
> — *from* Art and Fear, *by David Bayles and Ted Orland*

> *"Sometimes it's way faster to go a bit slower."*
> —*Jim Krause*

> *"I leave it to other people to live on the edge; most likely, I'd fall off."*

> *"As a photographer, do I change the precise moment that I'm trying to capture by my presence? Am I changing what would have happened by trying to be perfectly objective?"*

> *"It's better to get hurt by the truth than comforted by a lie."*
> —*Khaled Hosseini*

> *"There are no shortcuts to anyplace worth going."*
> —*Beverly Sills*

> PETRICHOR /ˈpɛtrɪkə(r)/: the smell of rain on dry ground

> *"We don't see things as they are, we see things as we are."*
> —*Anais Nin*

George Carlin once said that when he notices something, he writes it down. Not everything he writes down is necessarily funny, at least not at the time. He'll come back to his writings later and see whether his perception has changed. I often thumb through my old journals to jog my memory and see relationships between events that were not always evident when I was busy living them.

15. Visualize first, Photoshop second.

Don't let the computer suck you in; do your mental homework first. Make sure you have the bigger concept of your work before you reach for a mouse. When I'm trying to solve a prob-

17

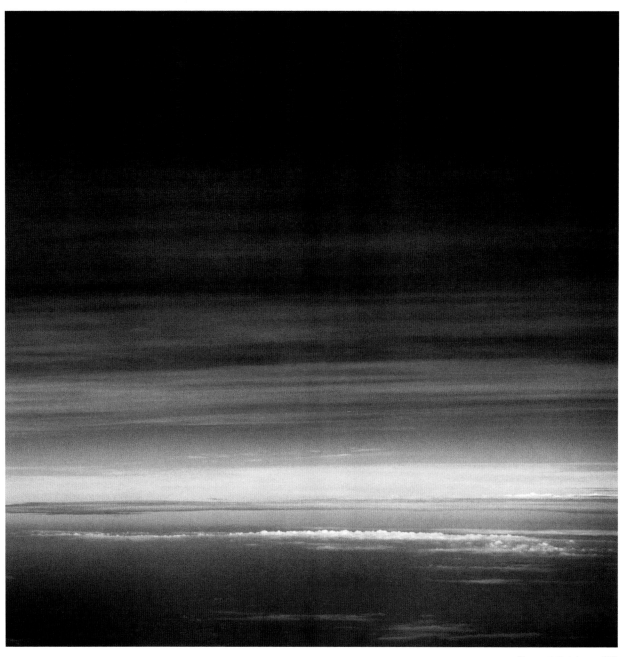

Singapore to Kuala Lumpur, 2001

lem or come up with an idea, the best tools I have are a pencil and paper. Don't be afraid to look for two or three good ideas—don't stop after one. Take a risk and go out on a limb. After all, you already have those first few ideas you can always go back to, but if you stop, who knows what you might be missing? If the creative juices are flowing, grab a bucket. And don't let your tools get in the way—learn the technology so well that it becomes an asset that allows you to focus on creativity and the ideas behind the content.

16. Replace your thoughts with intuition.

In graphic design—ideally—you learn design rules and then strive to break them when you can. It's very tough for me to leave the rules behind, but I find that when I do, something much more interesting happens. In the art world, there are no rules. So, instead of thinking about the piece, the message it conveys, what it's "for," and why I am creating it, I just focus on what's in front of me and follow my intuition. Go ahead and try to let go; run with a piece and see if it lifts like a kite in the wind. Remember, if you don't risk anything, you risk everything.

17. Play! Play! Play!

Give yourself assignments. It's a good habit to have a clear idea of what you want to achieve before you sit down with Photoshop, but there's no substitute for just sitting down and playing, experimenting, practicing—or whatever you want to call it. Some assignments I give myself, for example, are to make book and CD covers. After I read a book, I occasionally attempt a "better" design for the book cover. I try to create a cover image that better matches how I visualized the characters in the book, or what I think book is about. Find something you'll enjoy doing, and keep in mind that you don't have to play by yourself. Play "Photoshop tennis" with a friend. Start off by combining a few images in Photoshop, and then send them to a friend. Your friend then adds his own ideas to the file and sends it back. And so on. Crazy as it sounds, just sitting down with someone else to practice using Photoshop can teach you volumes about shortcuts and techniques.

18. Know when you're done.

The hardest part of working with the digital medium is that because it offers so many options for exploration, you must learn discipline. With Photoshop, the paint is never dry, the exposure is never fixed, and the print is never final. All of it can be done differently at any point, so part of the art form is knowing when to stop—realizing when you've said what you set out to say.

19

Singapore to Kuala Lumpur, 2001

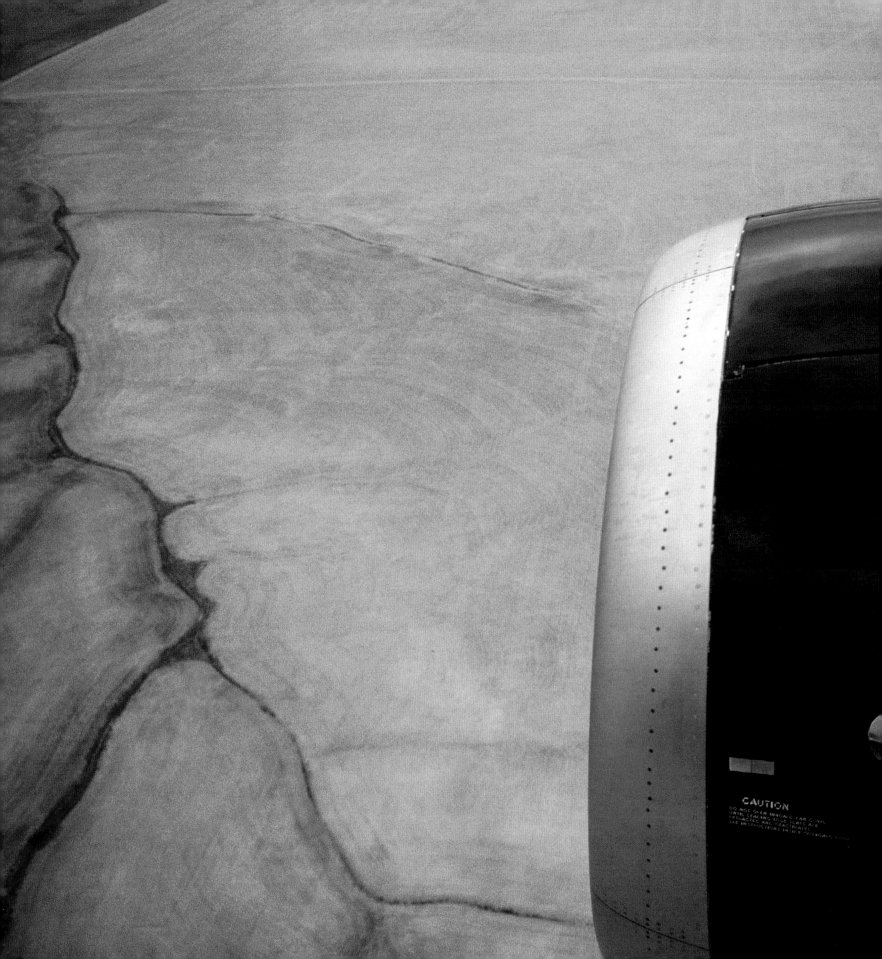

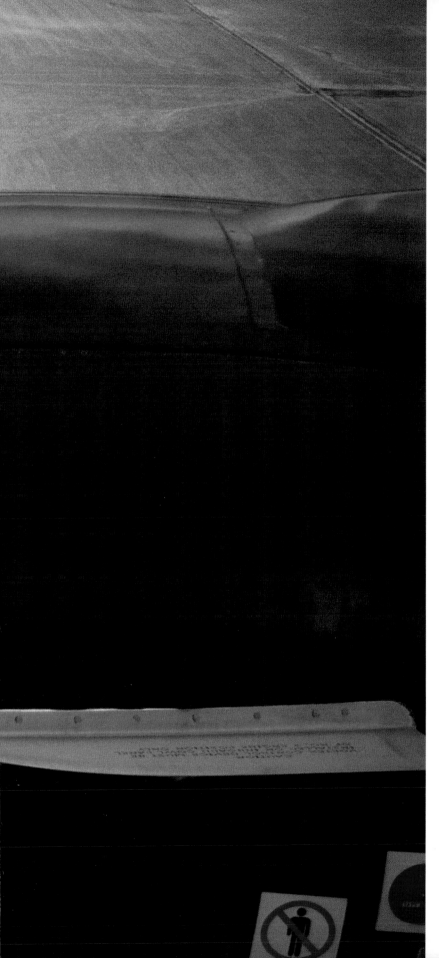

WINDOW SEAT

San Jose to Denver, 2002

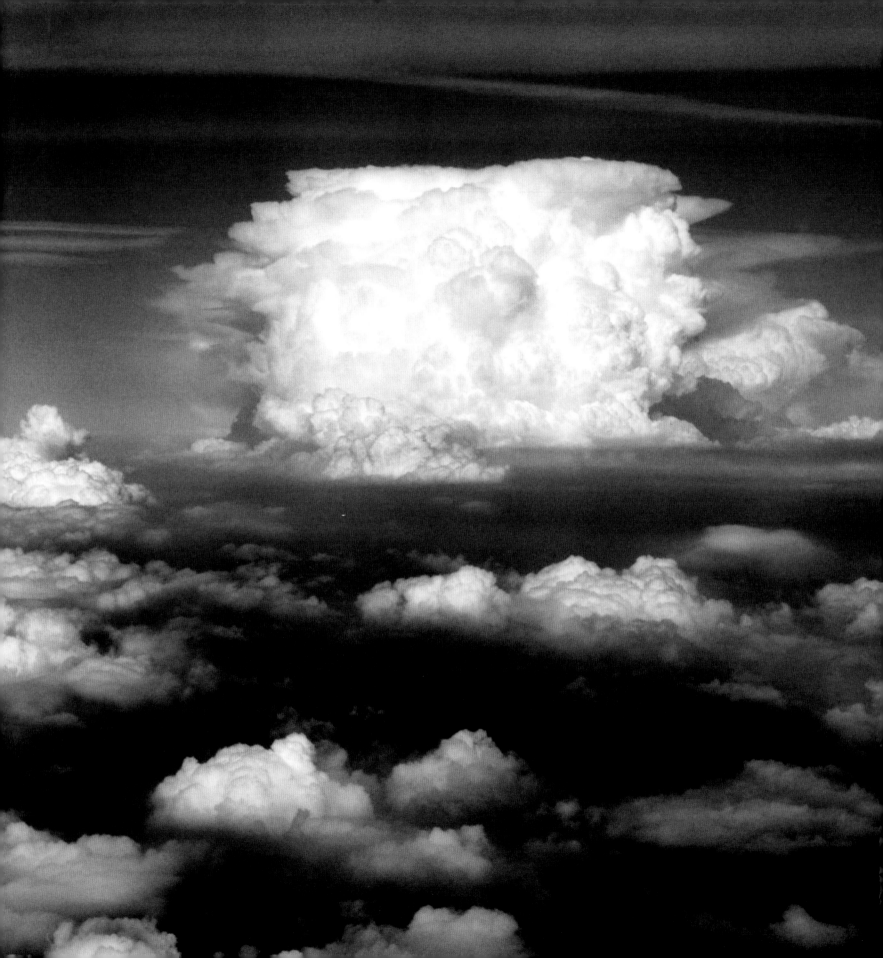

Desperately Seeking Creativity

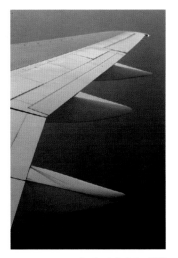

San Jose to Santa Ana, 2003

IN SOME WAYS, these images are the byproduct of a necessary part of my job: business travel. I began shooting photographs out of airplane windows because I needed a creative outlet. I was looking for an opportunity to photograph something, but all I had to look at were the insides of airports, cabs, hotels, and convention centers, and, for the life of me, I just couldn't find a way to make those places into interesting subjects to photograph.

I travel about 200 days a year, and, for better or worse, almost all of the places I have to go require that I fly to get there. As a result, I spend a great deal of time on airplanes in those tiny, cramped seats with little to do but try to work or read (since I don't watch many in-flight movies). Shooting photographs allows me to stay sane during those long flights and gives me something to focus on so that I'm doing more than simply moving between point A and point B.

I also have a bit of a handicap when it comes to flying: I am scared to death of it. I've always been afraid of flying, but during one particular 20-minute bout of turbulence in the middle of the Andes years ago, I found myself white knuckled, fingers embedded in the hard plastic arm "rests." The camera became a buffer between the reality of that moment and my own thoughts. When flying, after all, we are moving through the air at 500 miles per hour in a big metal tube, and, as I learned from my father (remember, he is an engineer), all metal has stress points that can fail.

I discovered that shooting pictures out the window allowed me to view the scenery in a different context: not as the earth some 30,000 feet below, but as an immense, constantly scrolling image. As long as I could see the world as an image through an eyepiece rather than as a harsh, physical reality, the threat was less real. I became a spectator—an observer of the scene rather than a part of it.

23

San Jose to Chicago, 2004

24

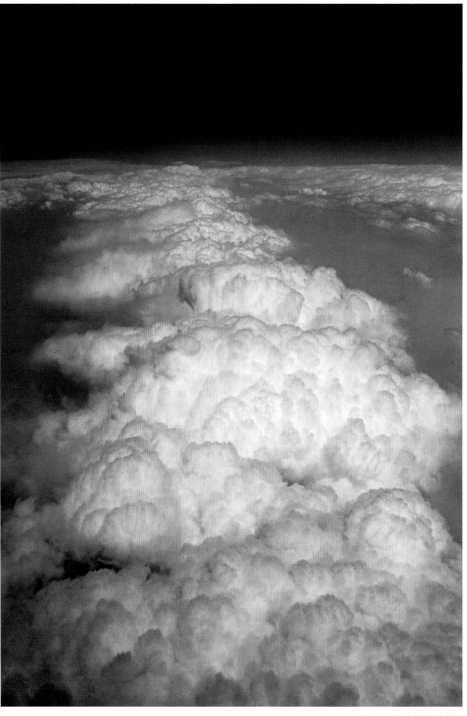

San Francisco to New York, 2002

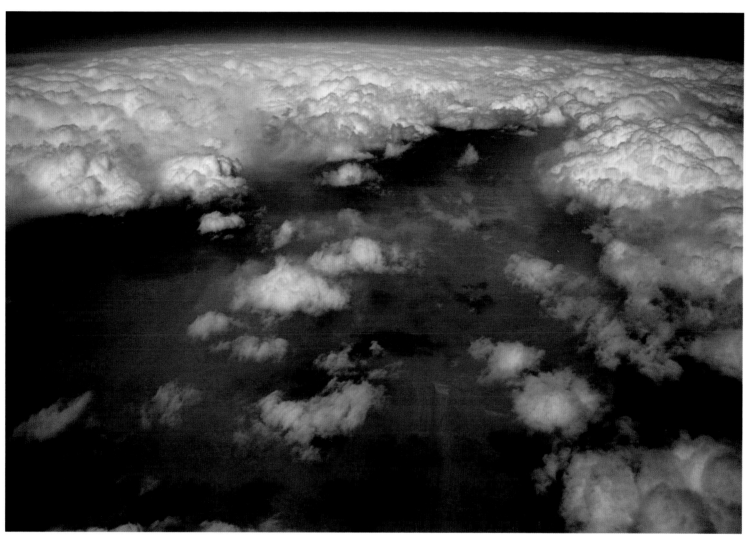

San Francisco to New York, 2002

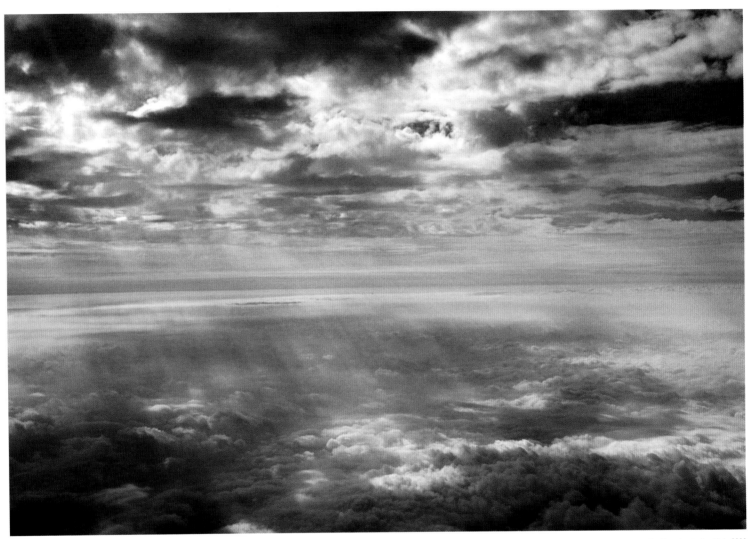

San Francisco to New York, 2000

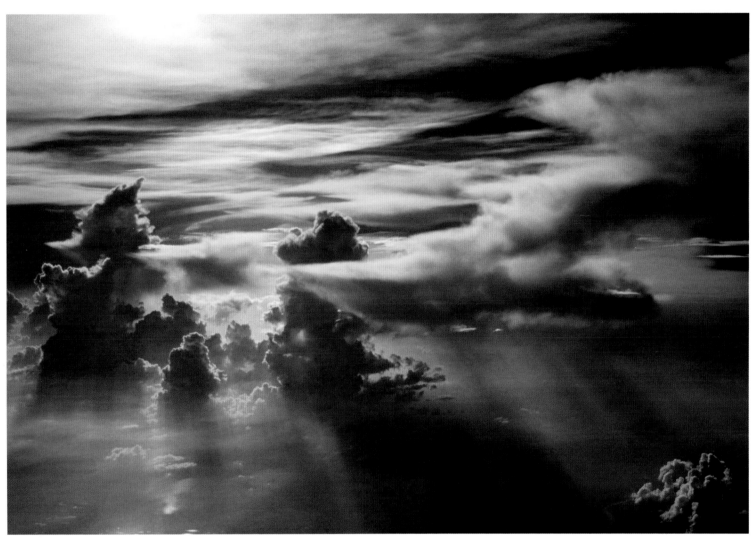

San Francisco to New York, 2000

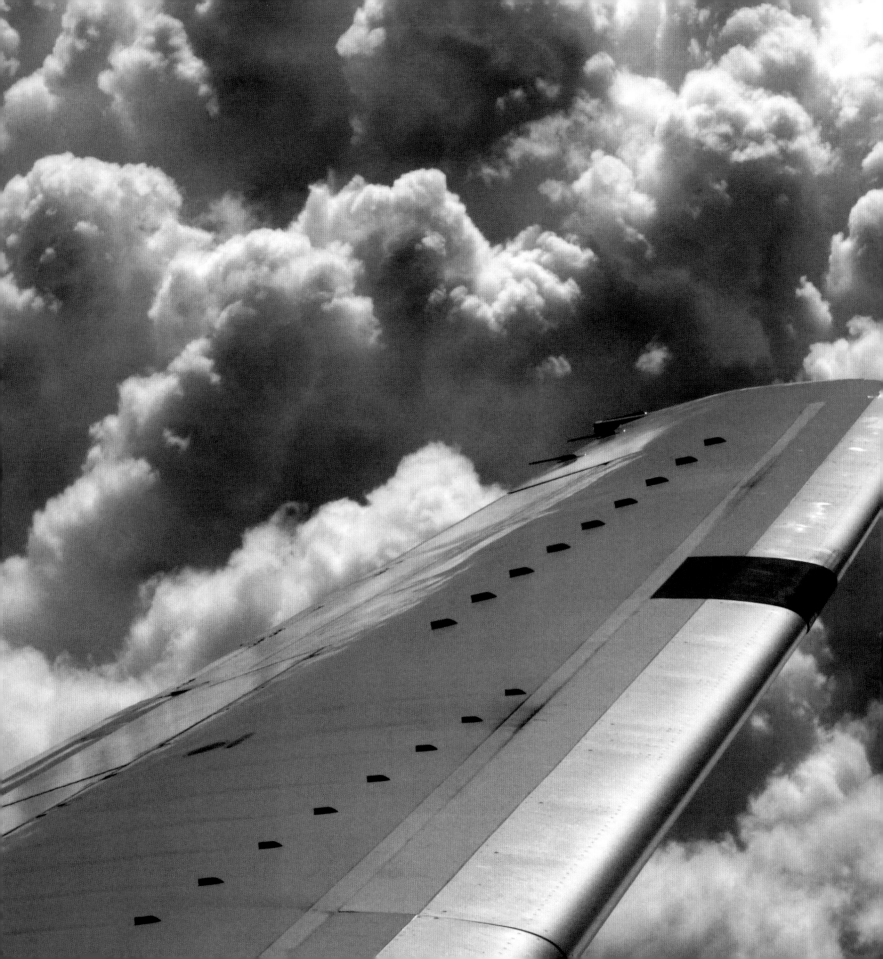

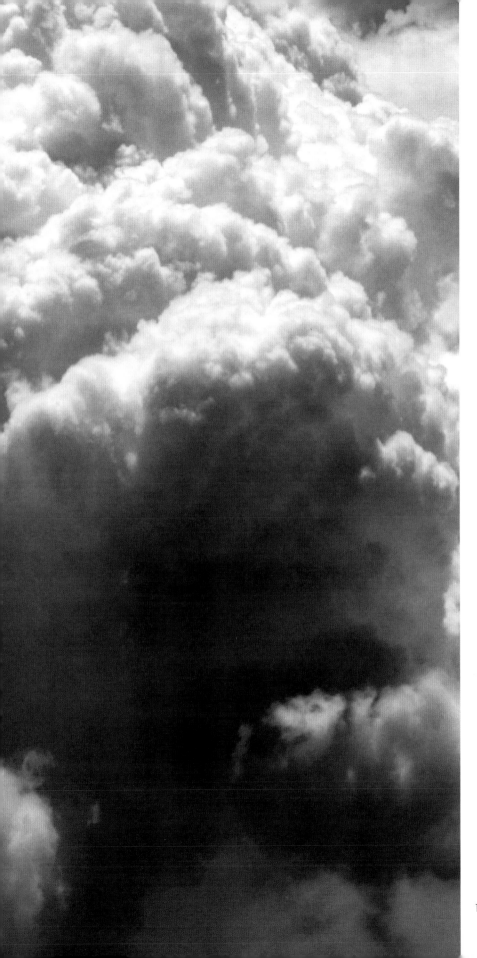

*I began shooting photographs
out of airplane windows because
I needed a creative outlet.*

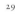 29

Tampa to Denver, 2003

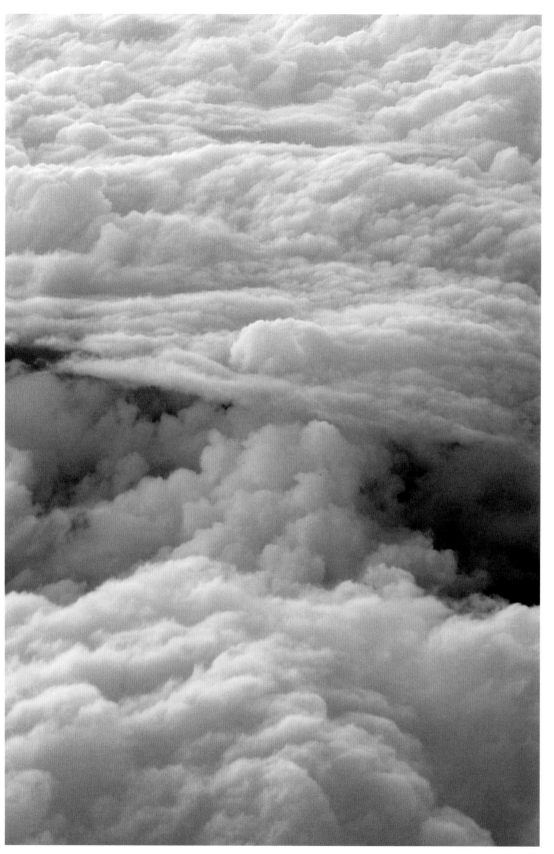

Denver to San Jose, 2003

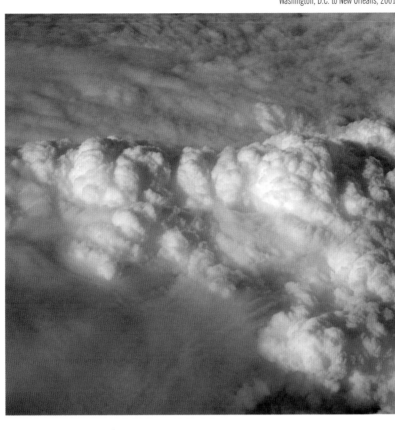

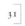

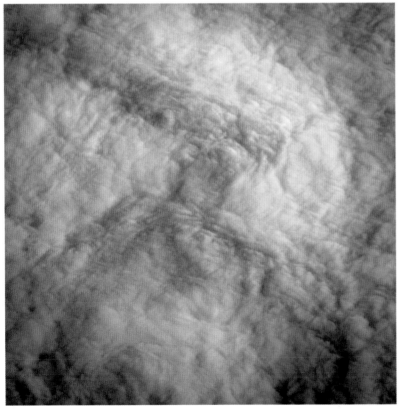

San Francisco to New York, 2000

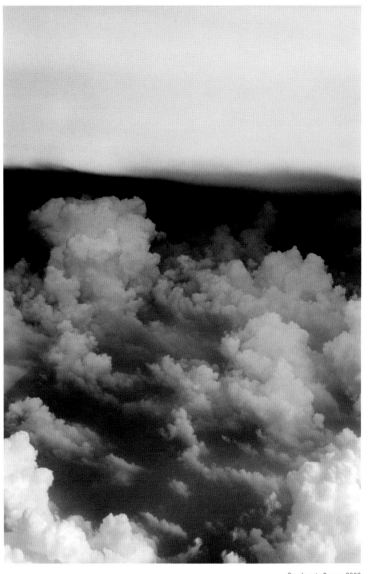

San Jose to Denver, 2003

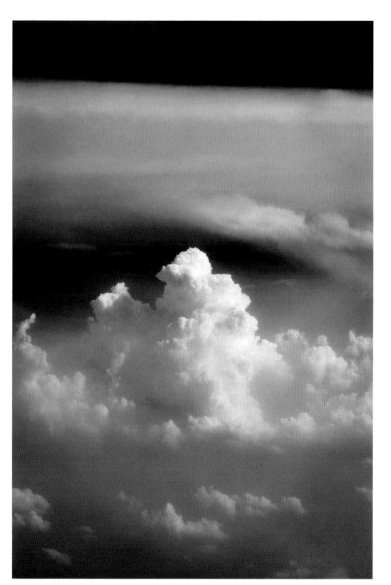

San Jose to Denver, 2003

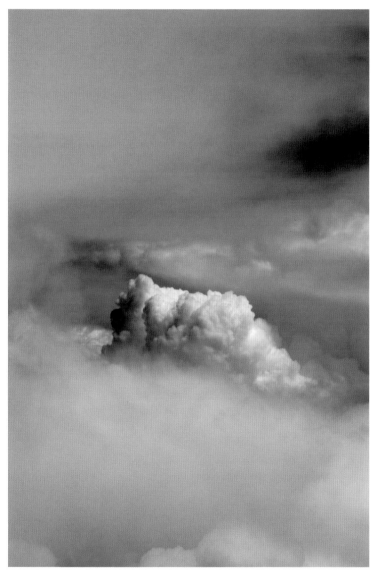

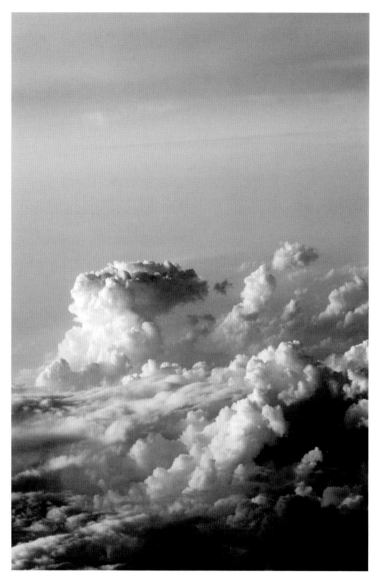

San Jose to Denver, 2003

San Jose to Newark, 2005

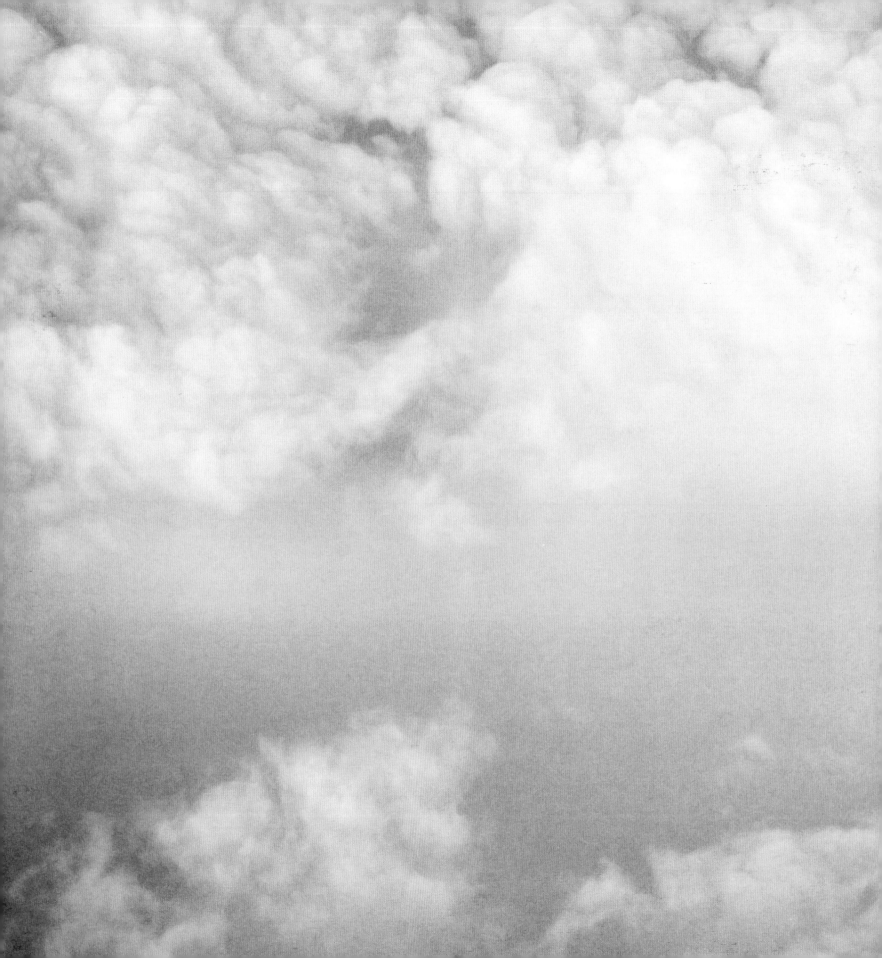

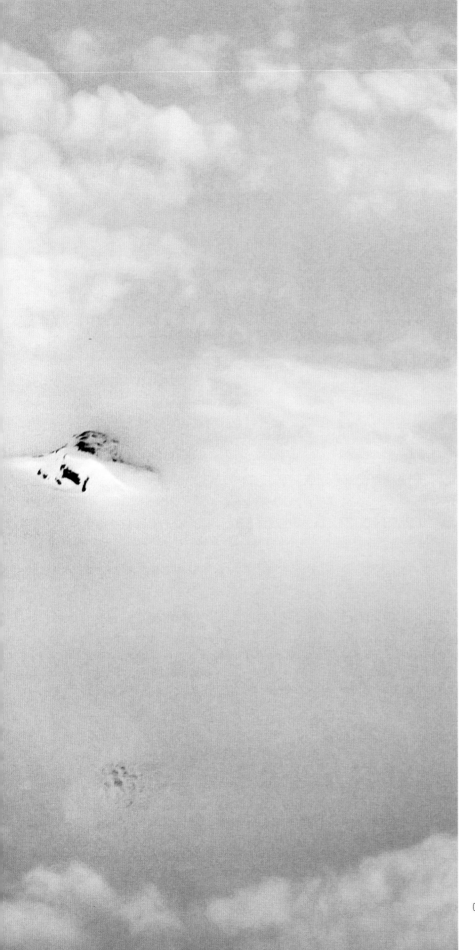

I became a spectator—
an observer of the scene
rather than a part of it.

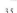

Chicago to Stockholm, 2005

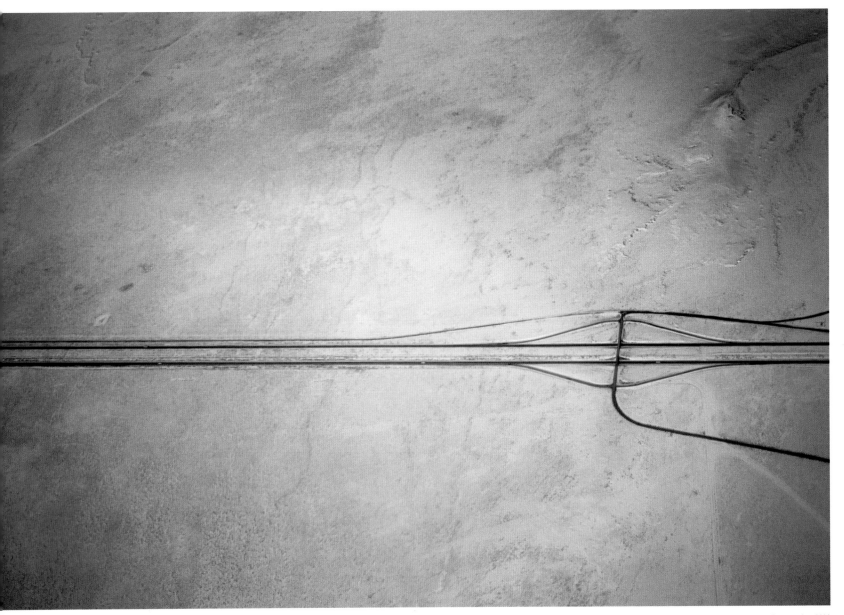

San Francisco to Salt Lake City, 2002

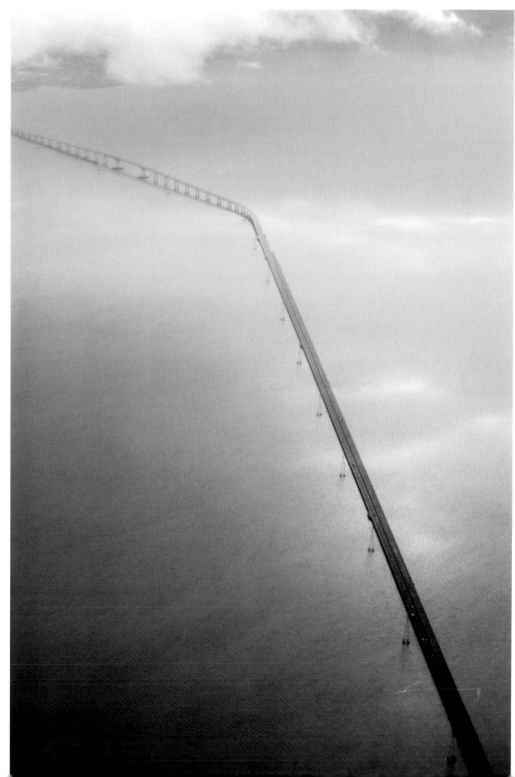

37

Vancouver to San Francisco, 2003

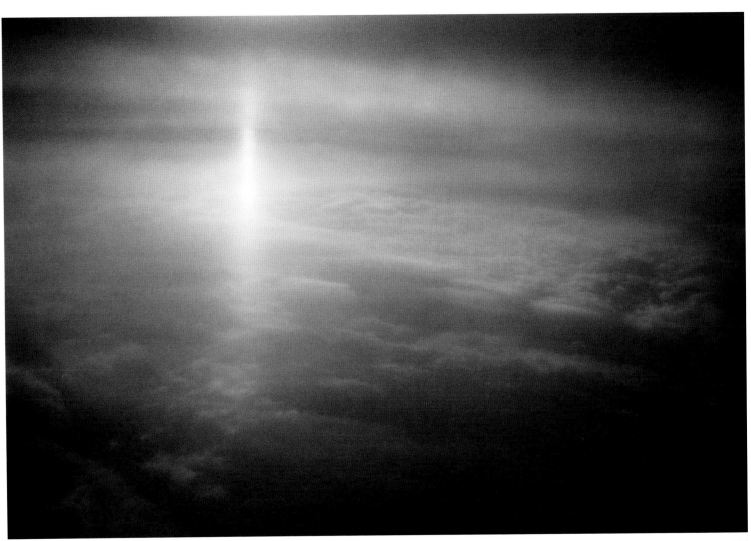

Atlanta to San Francisco, 2002

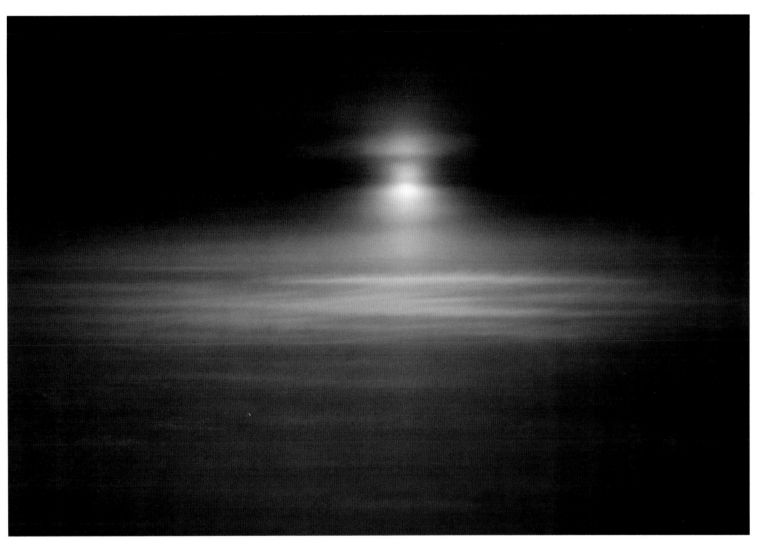

Atlanta to San Francisco, 2002

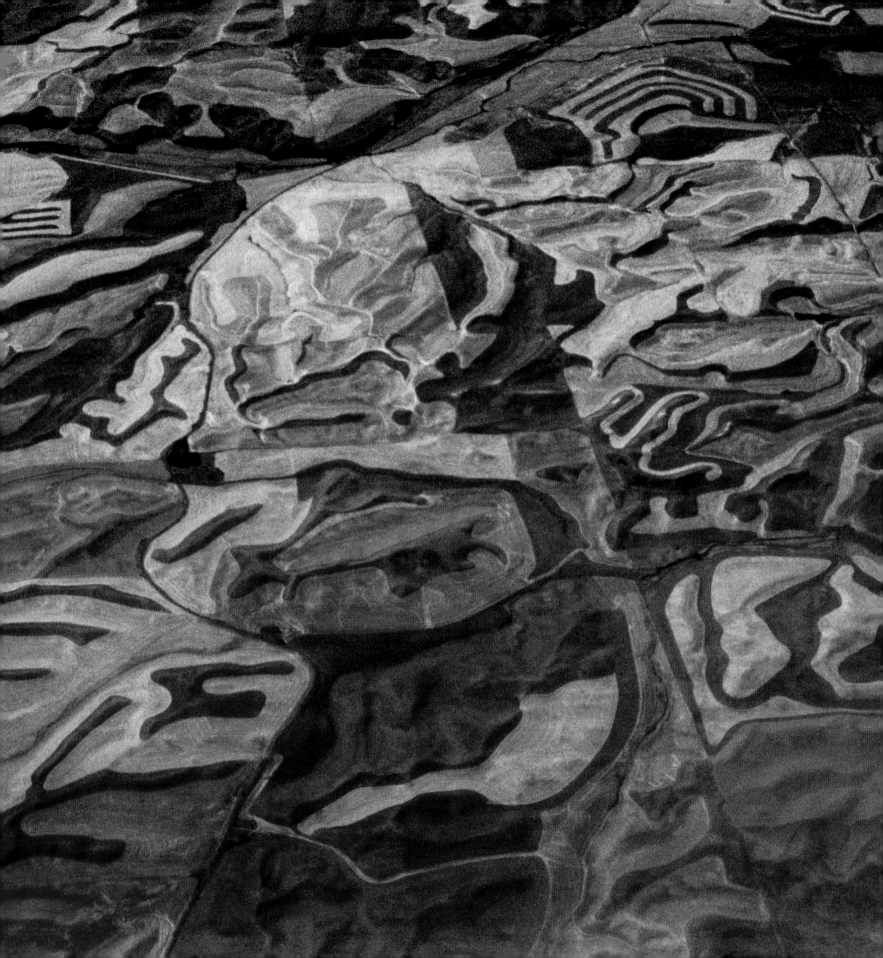

The Perfect Subject

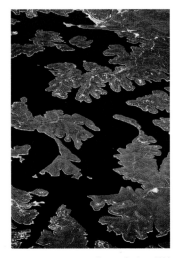

Tampa to San Jose, 2004

THIS PROJECT wasn't something I had intended to do; I certainly didn't spend a lot of time planning it, as I do with my digital illustrations. It was a natural outgrowth of who I am and what I was doing at the time. It seems incredible that I have been traveling around the world, photographing out of plane windows, for more than five years. I'm thankful for the opportunity to have shot so many variations on the same theme over such an extended period of time.

I find that airport security, transportation, public places, and travel in general can be stressful, so taking photographs out the window has been the perfect subject matter for me: it's calming as well as non-confrontational. It relaxes me to watch the clouds scroll by. I can shoot on my own time and my own terms. It's not an effort or a struggle; it's an easy exchange, a natural conversation I have with all that surrounds me outside that window. I reach a certain peace of mind when I shoot photographs like these; it's almost a form of meditation. There are no deadlines, no requirements that I shoot a certain number of images, and no one else's expectations to meet.

For me, it's instinctive to look out that window. I think it's ironic that the video screens on newer planes are almost the same size as the windows, and that so many people prefer to watch the packaged, predictable, artificial, advertisement-laden content on the screen rather than marvel at what's outside their windows. No matter how much I travel, I will always appreciate what I'm seeing: the unique view from 36,000 feet.

41

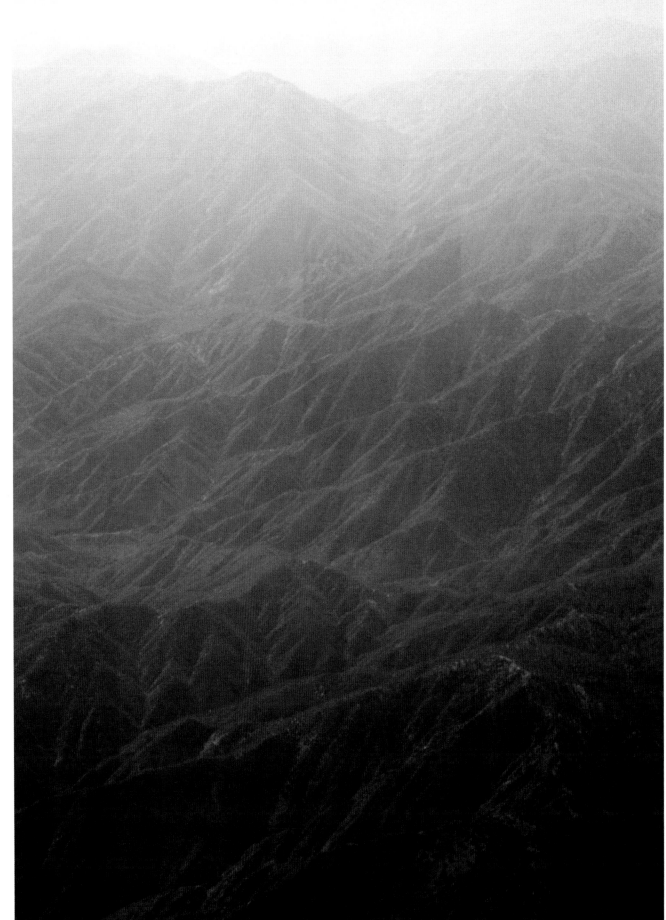

42

Denver to Missoula, 2000

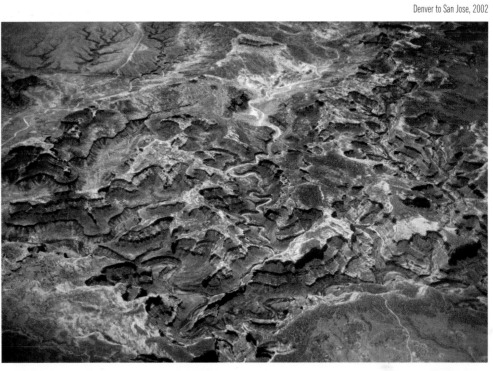

43

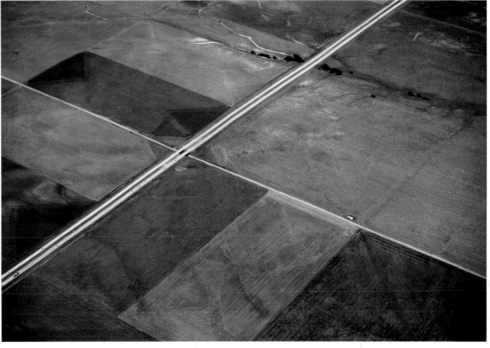

Tampa to Denver, 2001

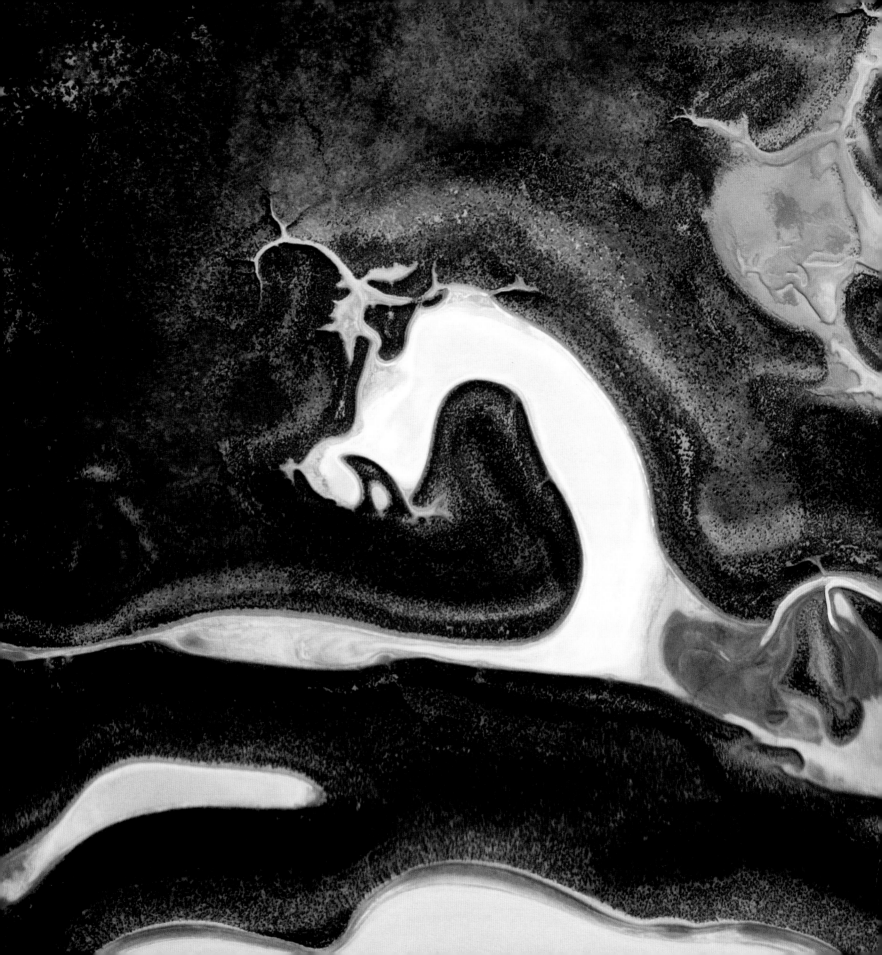

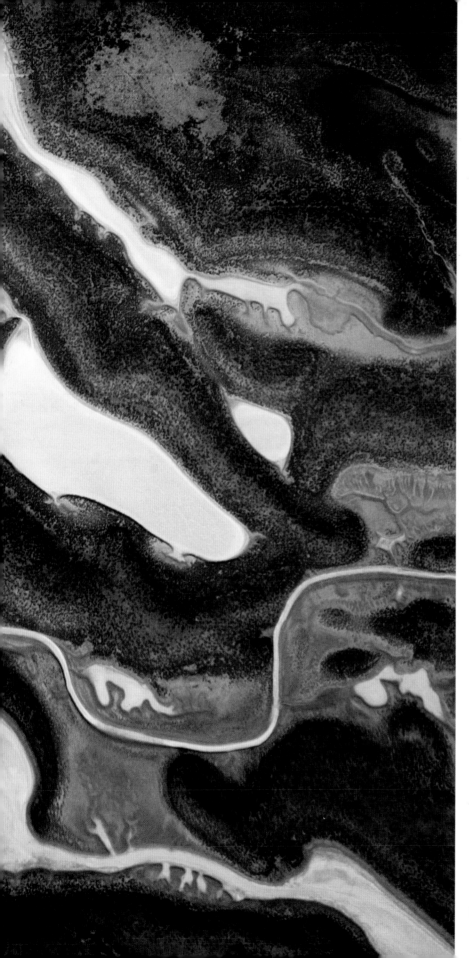

No matter how much I travel,
I will always appreciate what
I'm seeing: the unique view
from 36,000 feet.

San Jose to Los Angeles, 2004

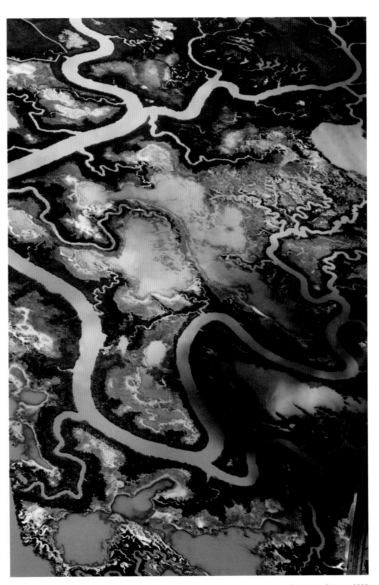

San Jose to Chicago, 2005

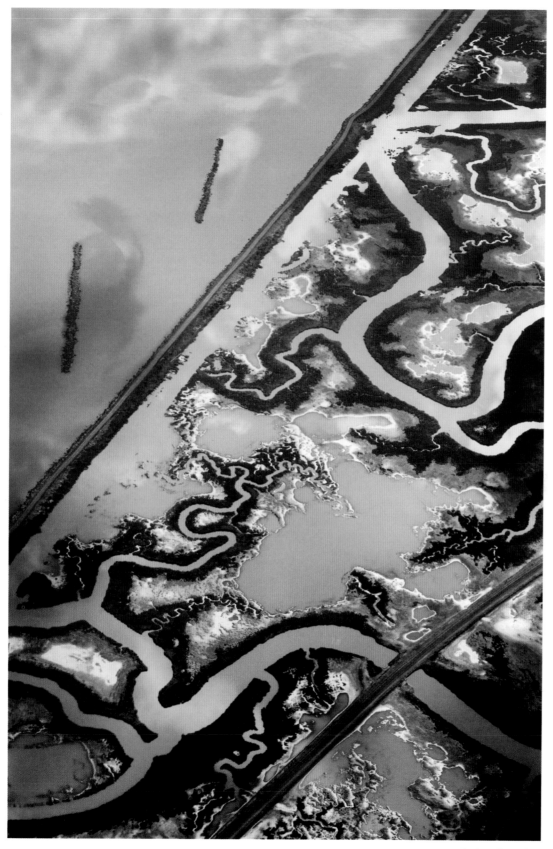

San Jose to Chicago, 2005

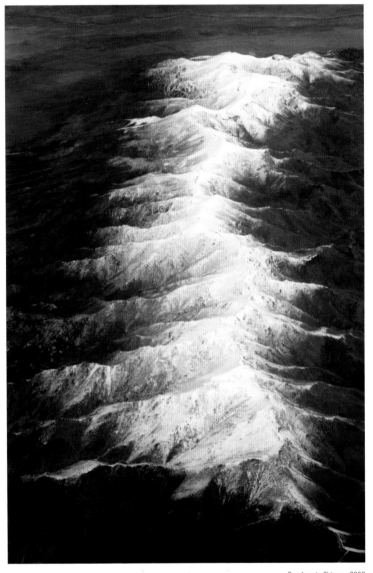

San Jose to Chicago, 2003

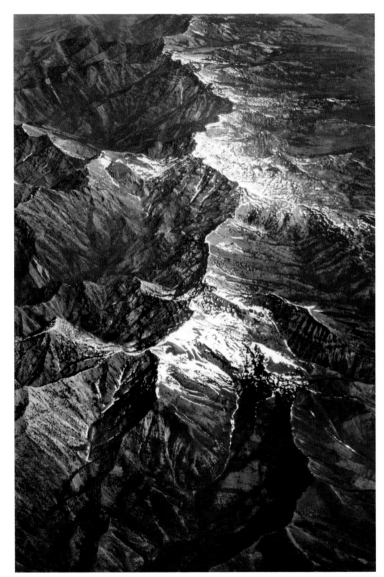

San Jose to Chicago, 2005

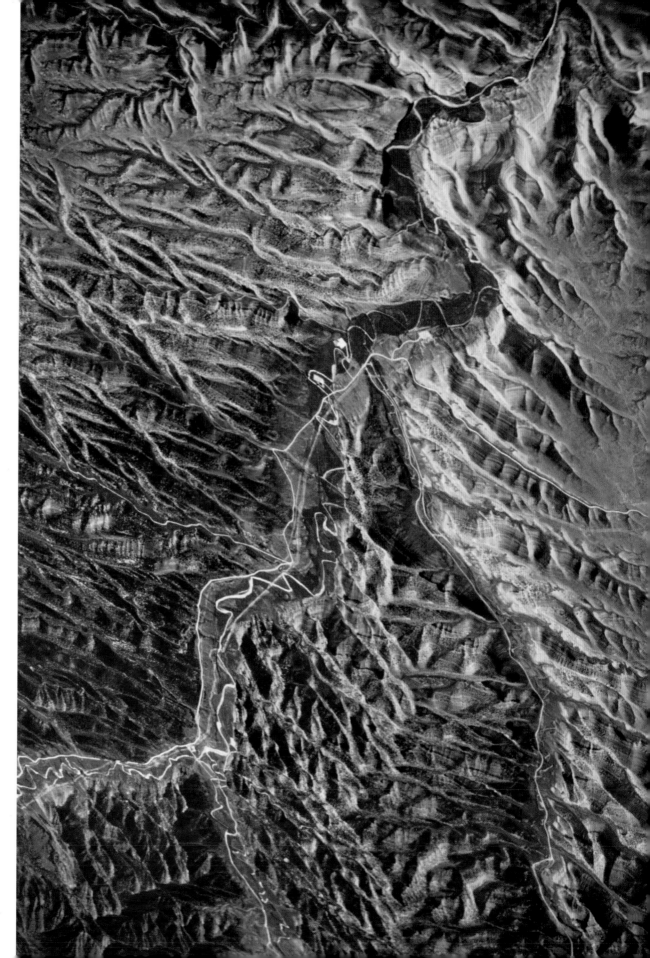

San Jose to Tampa, 2001

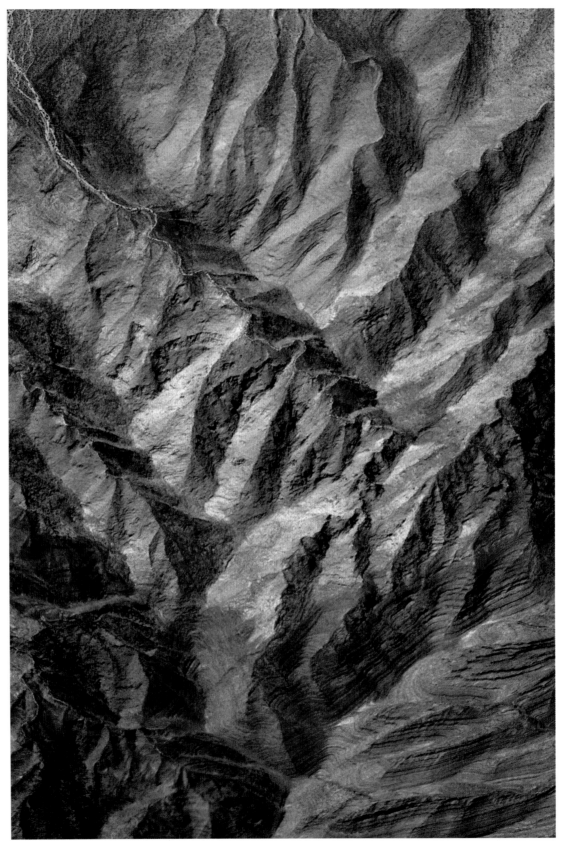

San Jose to Las Vegas, 2004

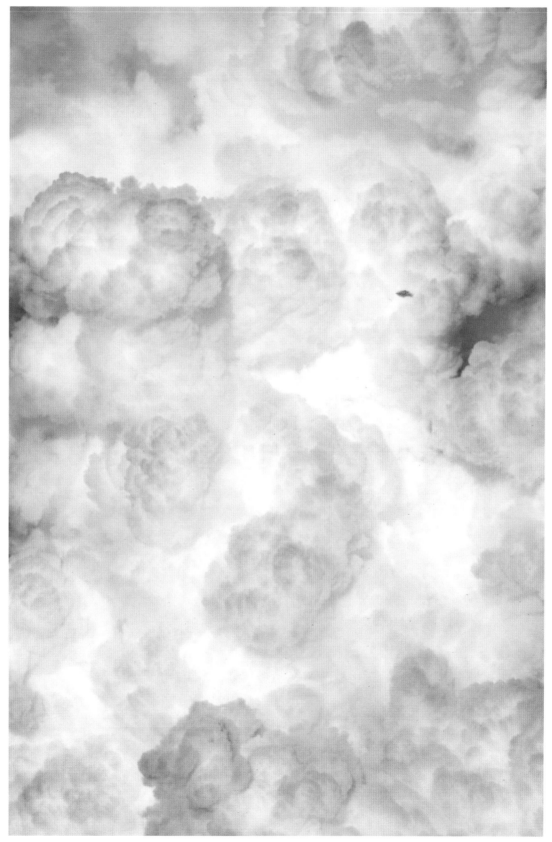

Tampa to San Jose, 2004

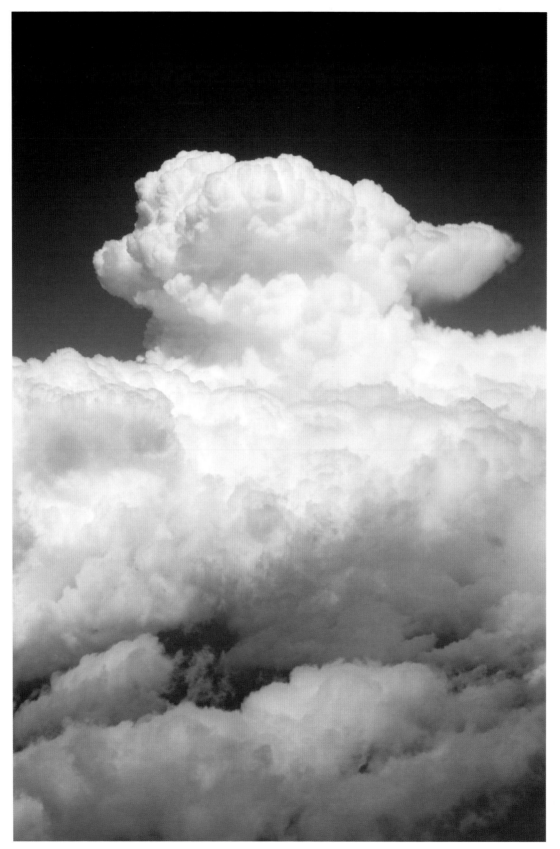

San Jose to Denver, 2003

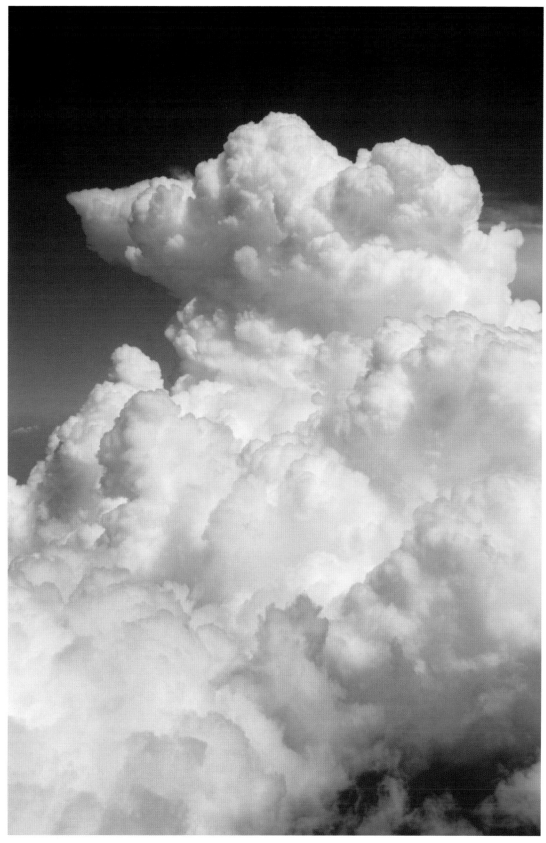

53

San Jose to Denver, 2003

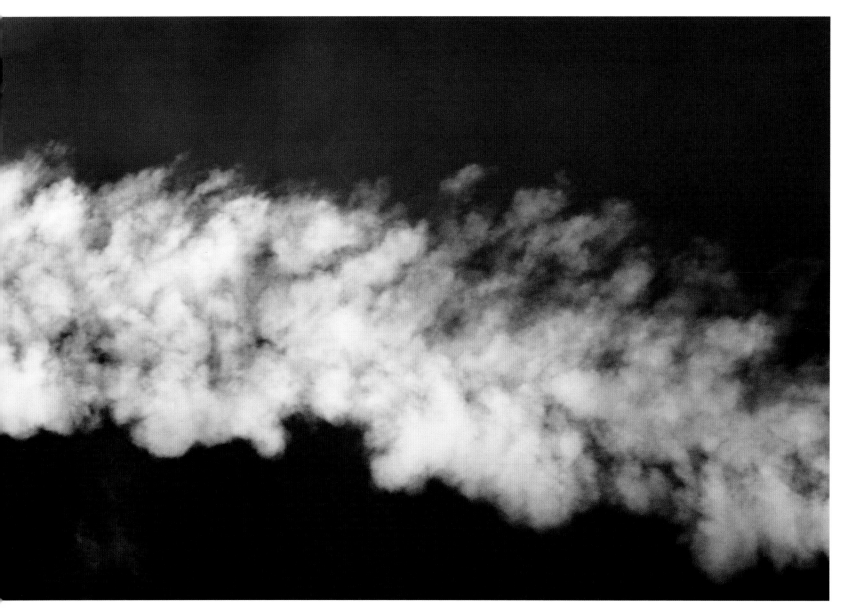

Chicago to Hartford, 2005

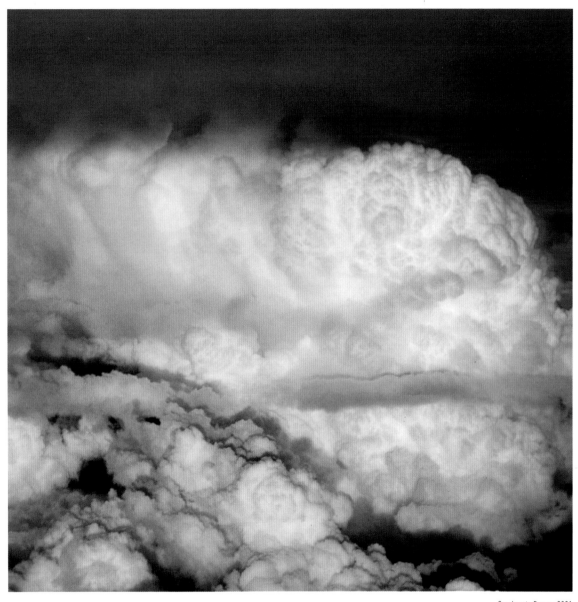

San Jose to Denver, 2001

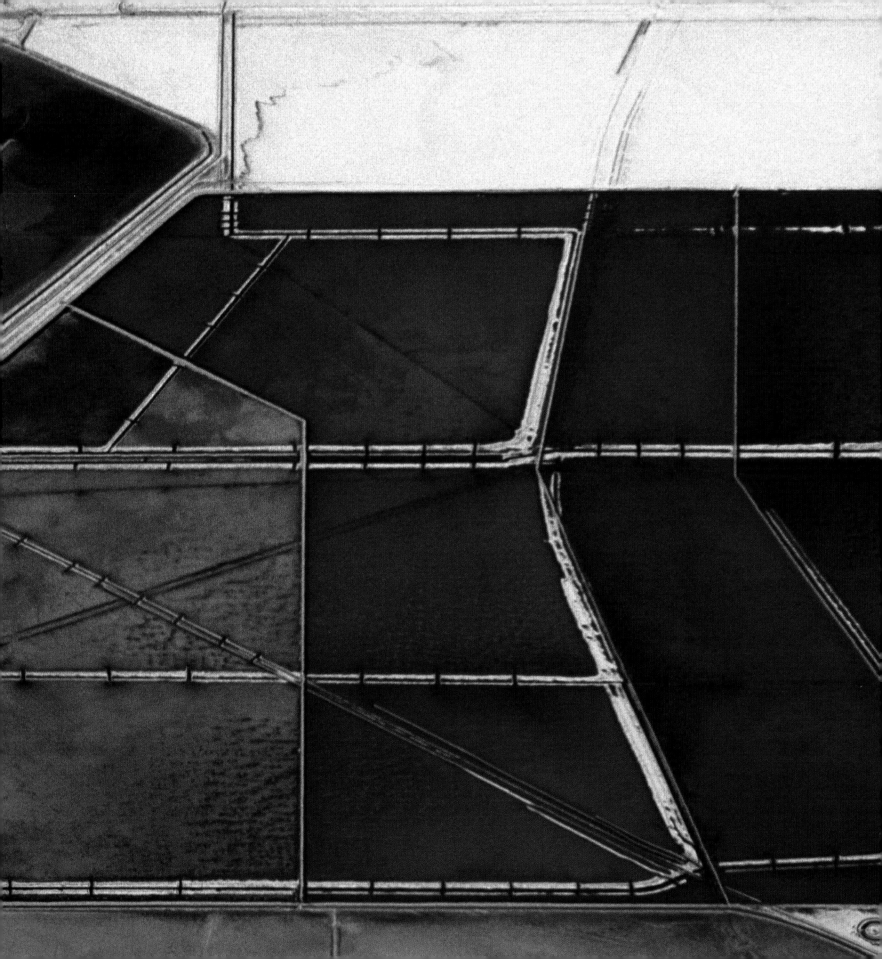

Control

San Jose to Chicago, 2005

CONTROL of your subject, or the lack thereof, is always a factor in photography. For example, I certainly didn't sculpt the clouds myself, choose the color palette, or pick the time of day. But I did focus on the images that moved me. The images range from realistic portrayals of the things people expect to see from airplane windows to images so surreal that unless you knew what they were in advance, they would never make you think "clouds" or "farmland."

Ideally, I'd love to have control of the plane so I could go see what kinds of images I could find. But the reality is that the cost of taking such a trip would be prohibitive to say the least. Besides, by being a passenger rather than a pilot, I think I have been able to see a greater diversity of surfaces, colors, lights, and angles than I would have discovered on my own. Sometimes it's just good to see what passes by the window. I don't think an image is ever accidental, even when the circumstances under which you to choose to capture that image are seemingly random. I am always reminded of this when I take the same United flight that I've taken 50 times before and see something completely new. It's unreal how diverse the view can be depending on the weather, the time of day, etc.

Of course, this can be frustrating when you see an image that you want to capture, but have to let it go because you have no control over the flight path of the plane. You can't ask the pilot to go back, wait for sunset, circle around again, or turn a little bit to the left. If you are unfortunate enough to sit over the wing, your field of view is reduced to almost nothing, and if you sit behind the jet, all of your images will be wavy from the exhaust. Not to mention that you can't always get a window seat!

57

San Francisco to Salt Lake City, 2003

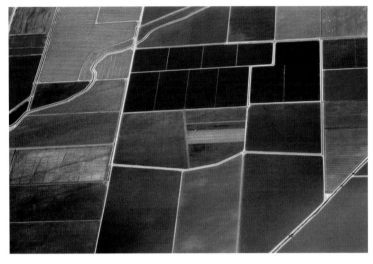

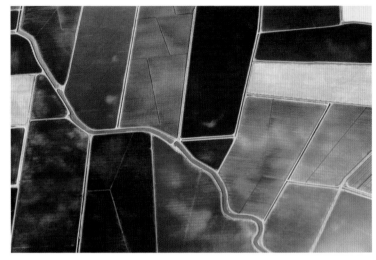

58

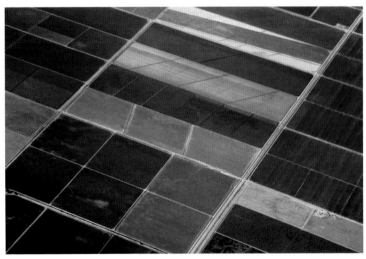

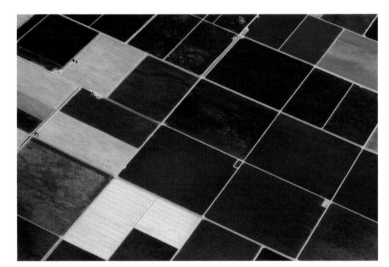

Chicago to San Jose, 2005

Denver to San Jose, 2003

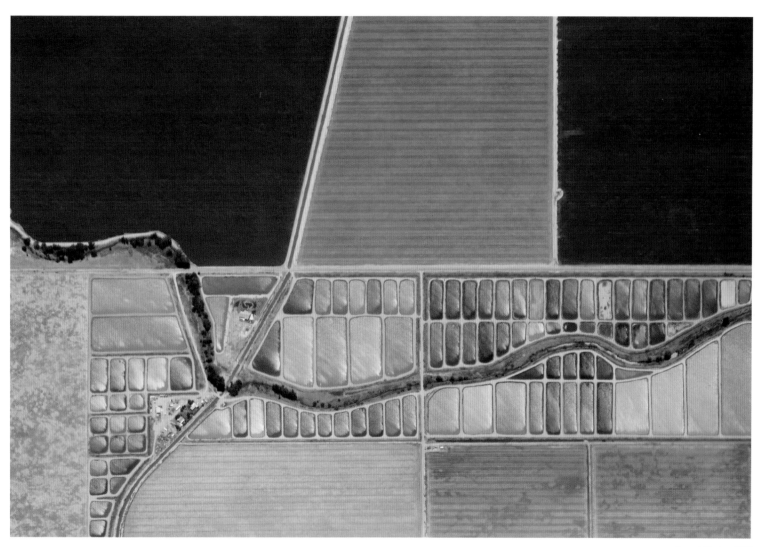

Denver to San Jose, 2003

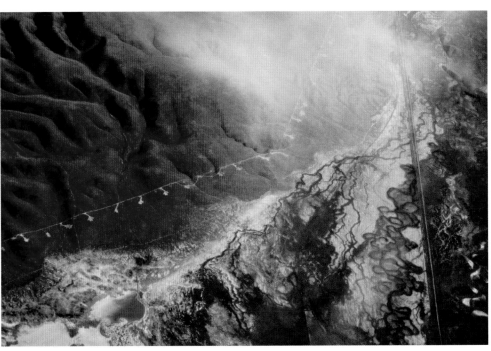

San Jose to Chicago, 2005

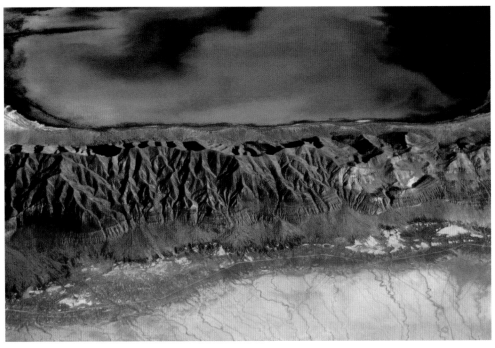

San Jose to Chicago, 2005

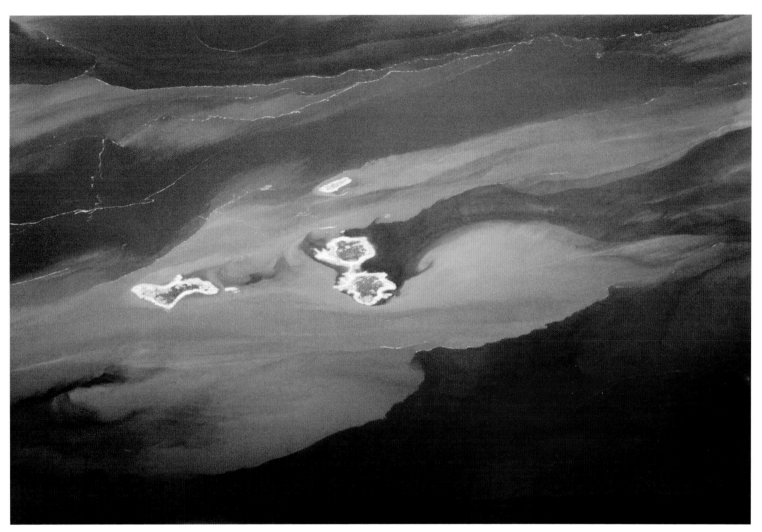

Chicago to San Francisco, 2005

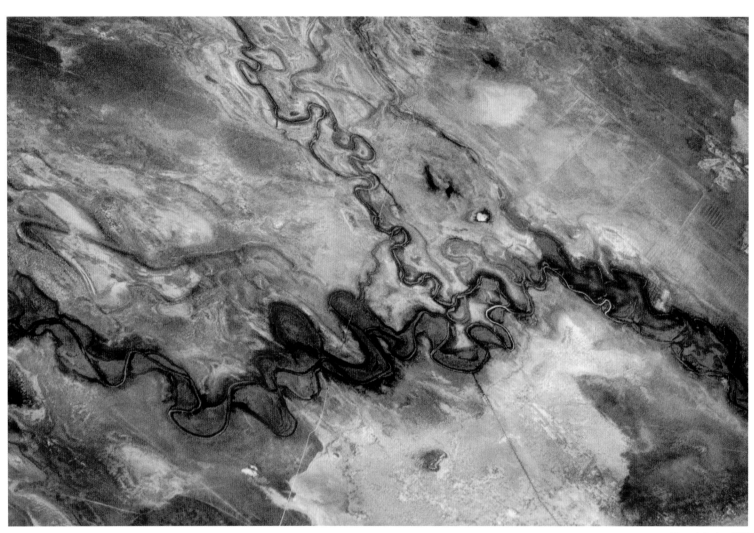

Chicago to San Jose, 2005

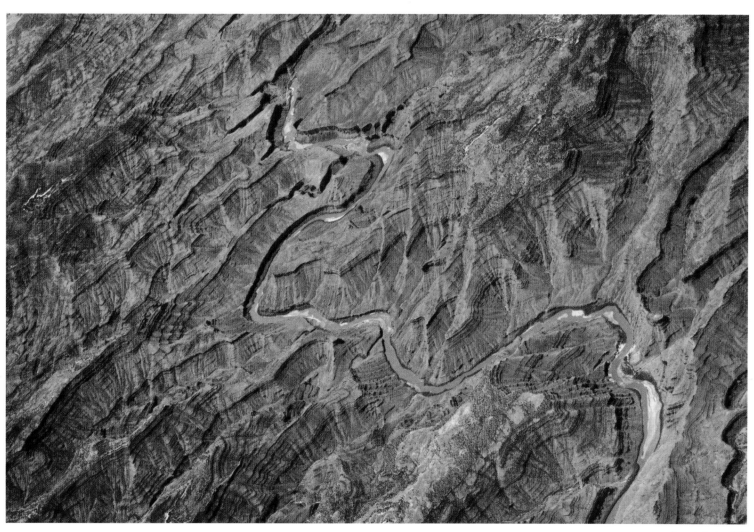

63

Denver to San Jose, 2003

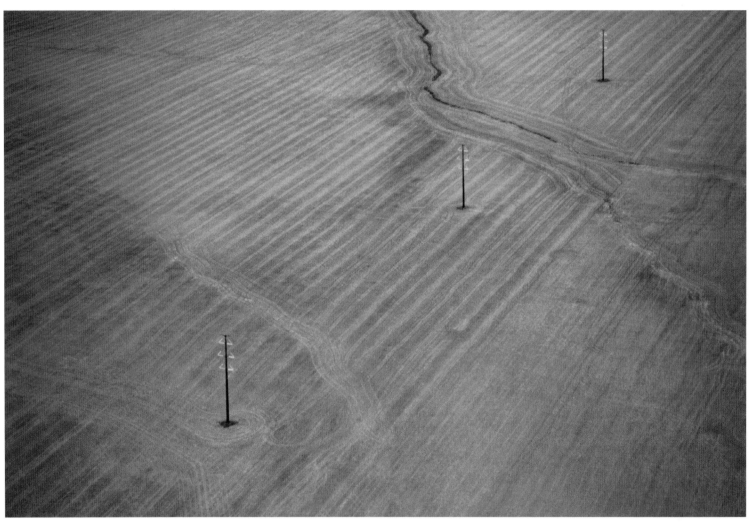

San Jose to Denver, 2002

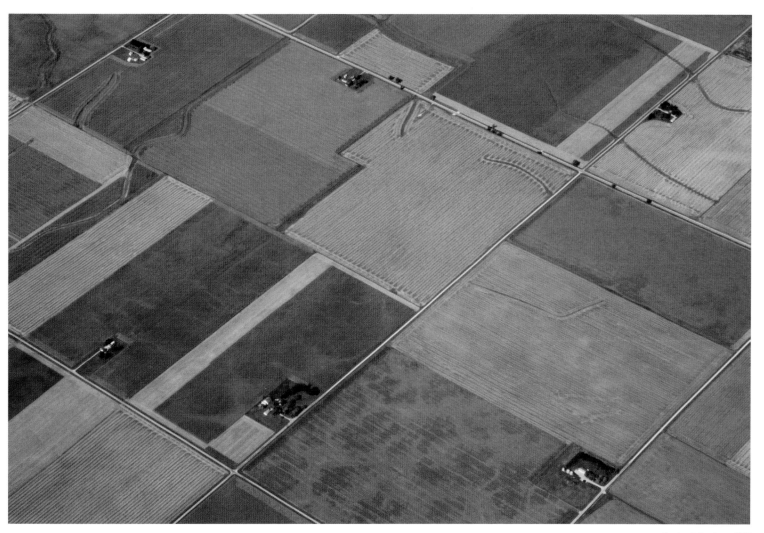

San Jose to New Jersey, 2003

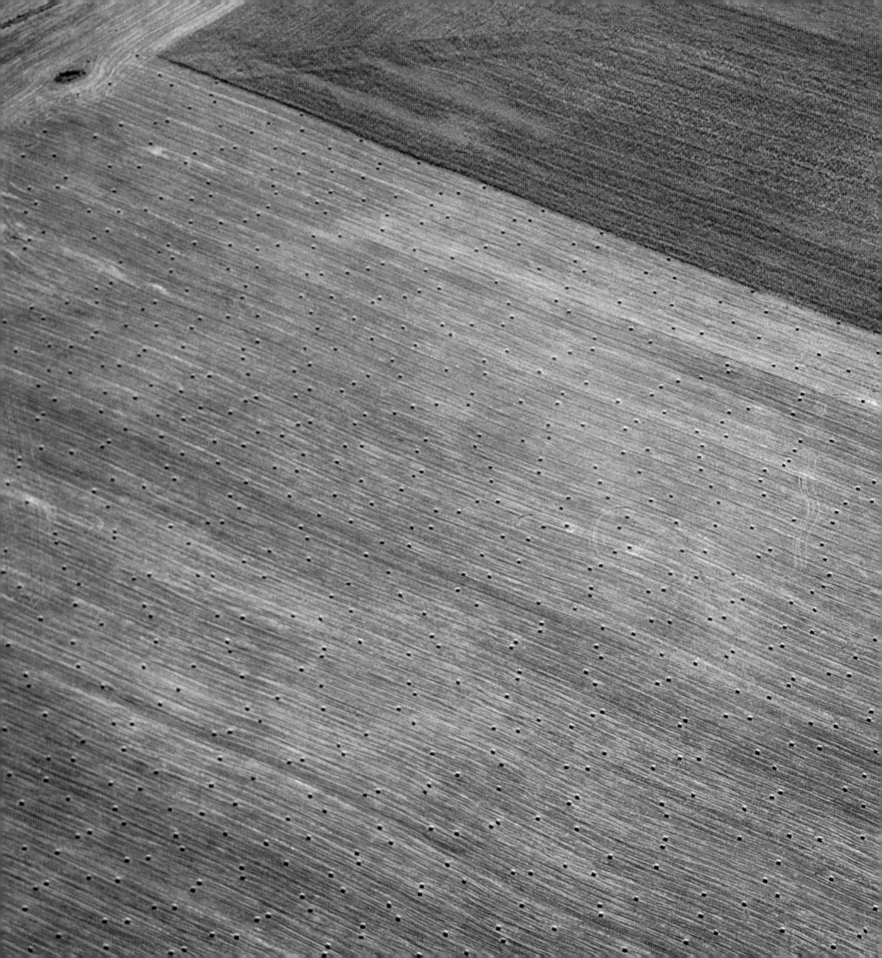

…*by being a passenger rather than a pilot, I think I have been able to see a greater diversity of surfaces, colors, lights, and angles…*

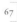

67

Tampa to Denver, 2001

Capturing a Moment

San Francisco to Kahului, 2000

I'M CERTAINLY NOT the only person who has ever snapped a photo out the window of a plane. From a practical standpoint, however, many people have a difficult time shooting decent photos this way. If you take an average point-and-shoot film camera and aim it out the window, you are pretty much guaranteed to get a washed-out image with reflections, lens flare, and an in-focus window and an out-of-focus cloud. Likewise, when the sun is setting and those wonderful pastel colors envelope you, it's probably dark enough that the flash will automatically trigger, leaving you surprised and definitely disappointed by the results. These are only a few of the difficulties of photographing through a plane window.

The events of 9/11 have had a profound effect on the process, making capturing images even more difficult. There was a time when I could huddle against the window with a black sweater over my head to hide reflections from the glass, but now I'm hesitant to do anything that looks suspicious. The flight attendants have even asked me to turn off my camera: "Anything with an on/off button must now be turned off." Then there's the grilling process that takes place before boarding a plane. It's not as bad with digital cameras as it is with film, since digital images obviously run a lower risk of being ruined by an x-ray device, but with all of the electronic equipment I carry, I fully expect to be pulled aside so that security can give my camera bag and computer the "digital sniff test."

It's interesting to me that none of my fellow passengers has ever asked me what I'm doing when I shoot photos out the window. I'm not sure if they think it's a waste of time (because they've tried it and their images didn't turn out well), if they're afraid to ask, if taking photographs comes across as a personal activity that wards off social interaction (like wearing headphones), or if they think it's simply my first time on a plane and I'm giddy about the experience.

Regardless, I love knowing that what they see and what I'm capturing are often completely different things.

Denver to Aspen, 2000

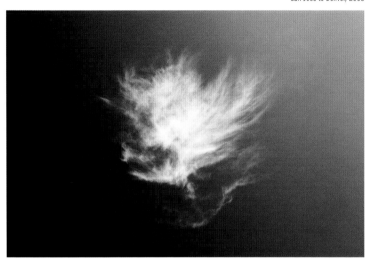
San Jose to Denver, 2003

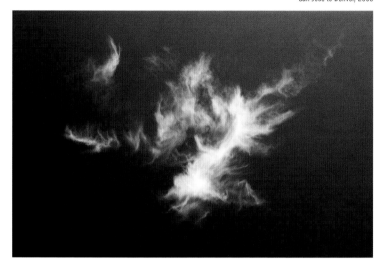
San Jose to Denver, 2003

70

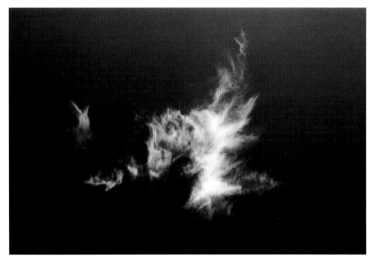
San Jose to Denver, 2003

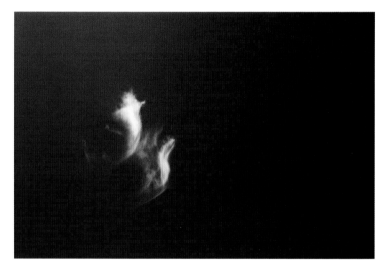
San Jose to Denver, 2003

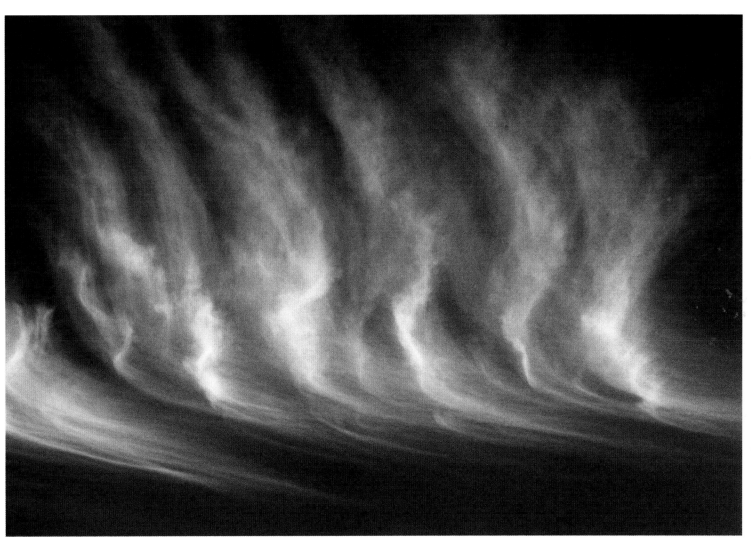

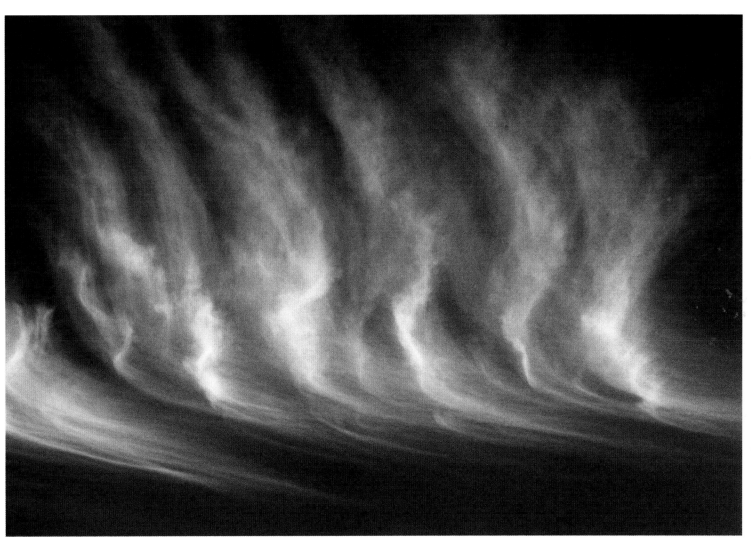71

San Francisco to Kahului, 2000

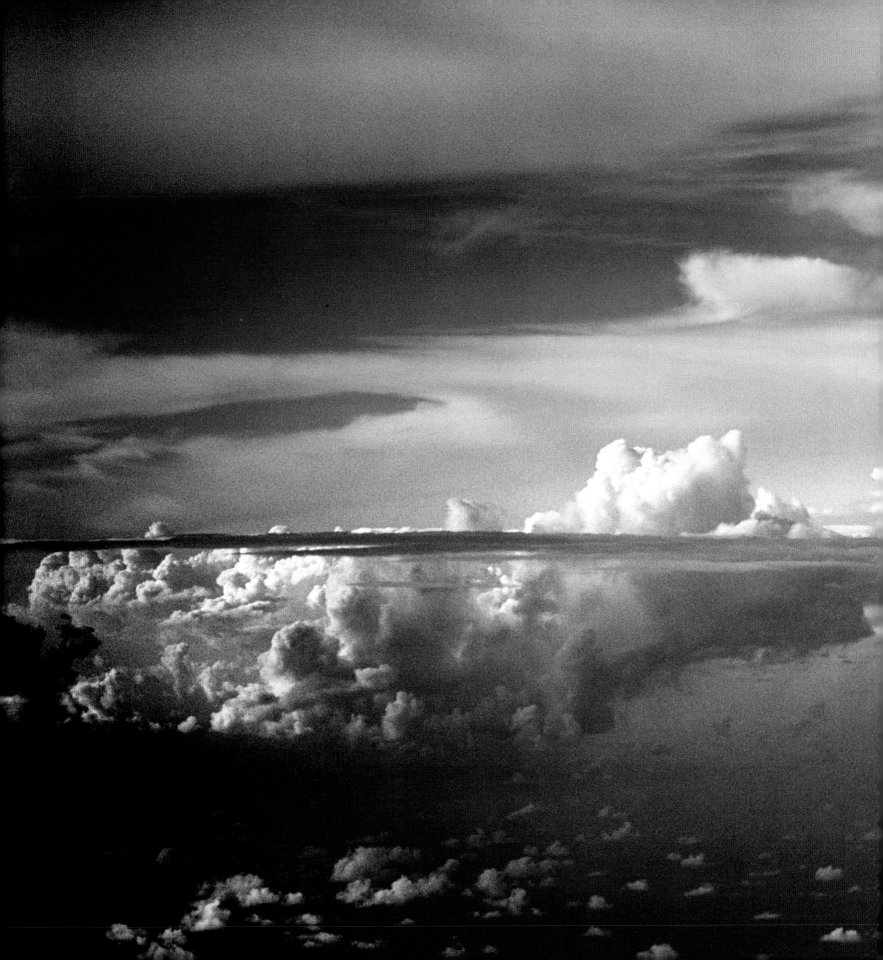

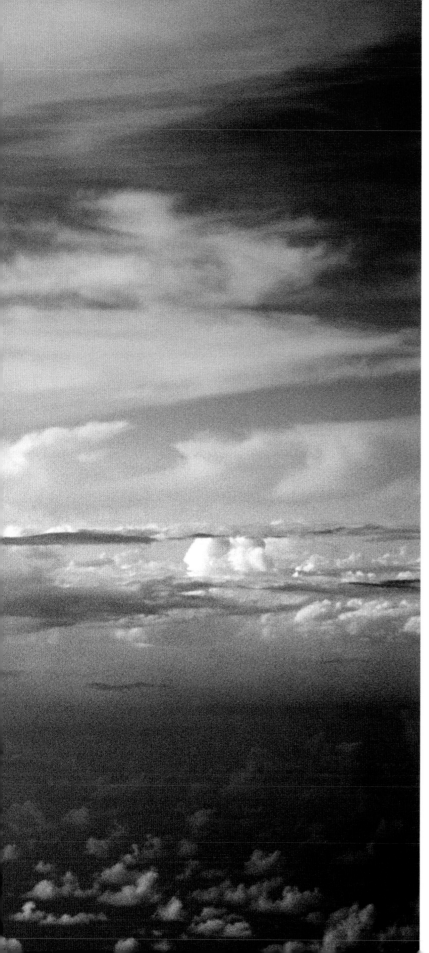

*It's interesting to me that
none of my fellow passengers
has ever asked me what
I'm doing…*

73

Miami to Raleigh, 2002

San Francisco to Houston, 2005

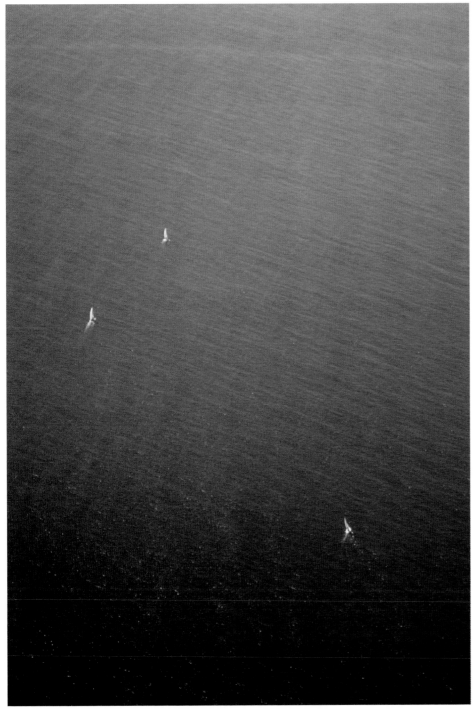

New York to Los Angeles, 2002

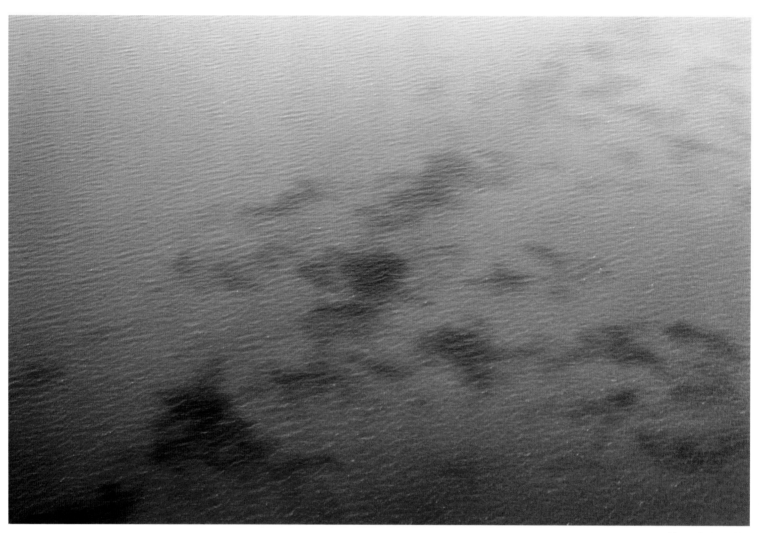

Atlanta to Stockholm, 2000

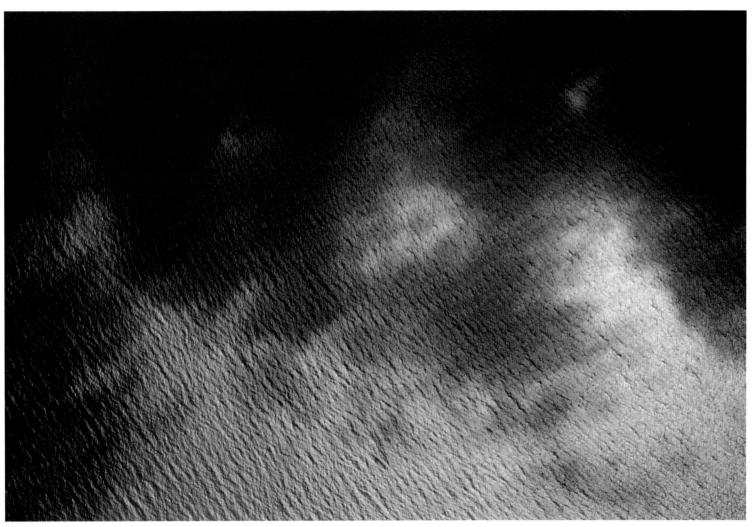

Atlanta to Stockholm, 2003

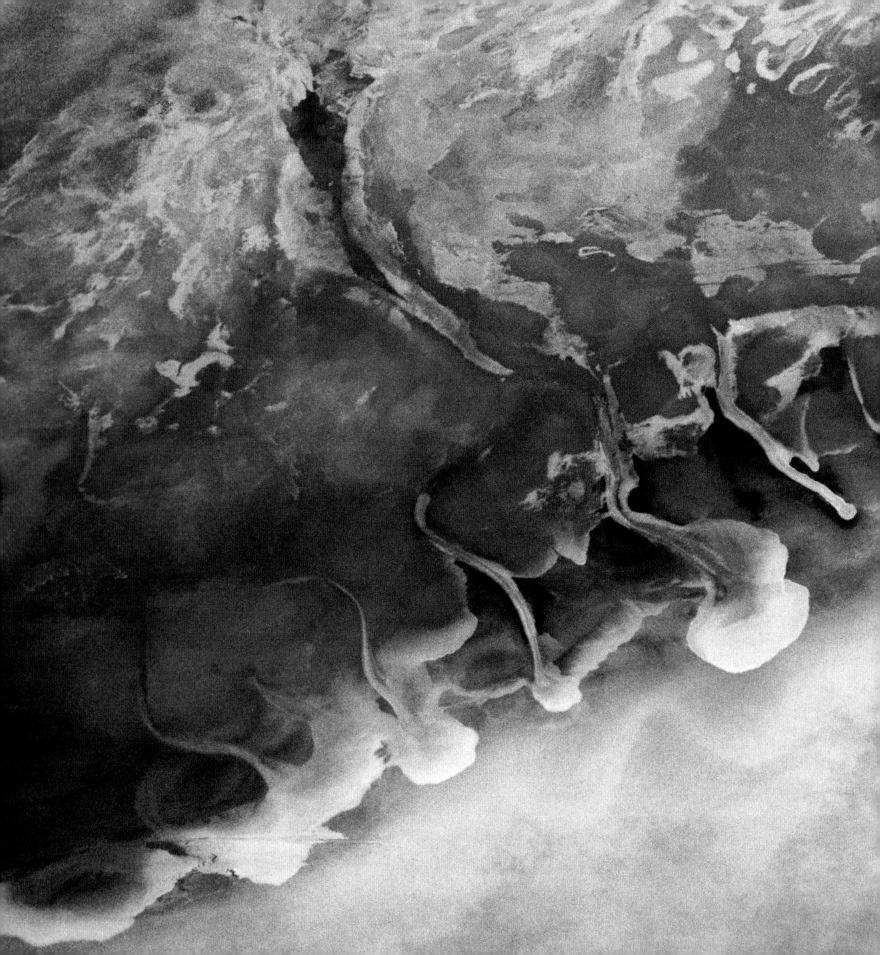

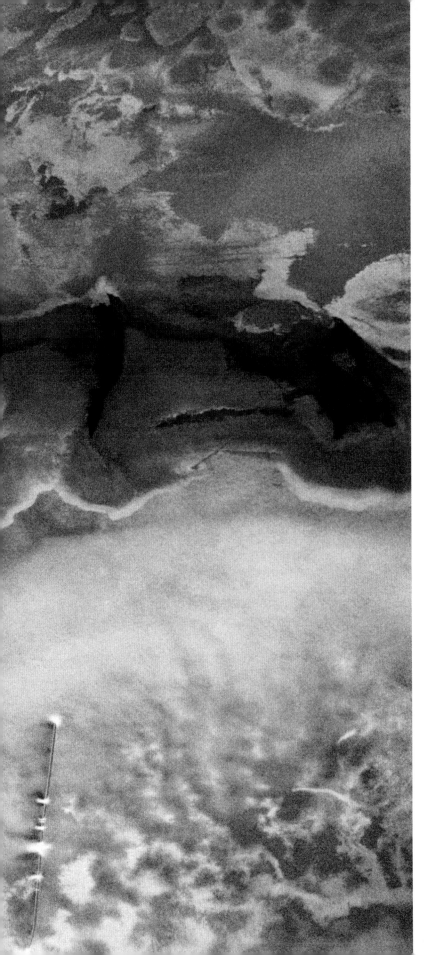

…I love knowing that what they see and what I'm capturing are often completely different things.

Denver to Las Vegas, 2004

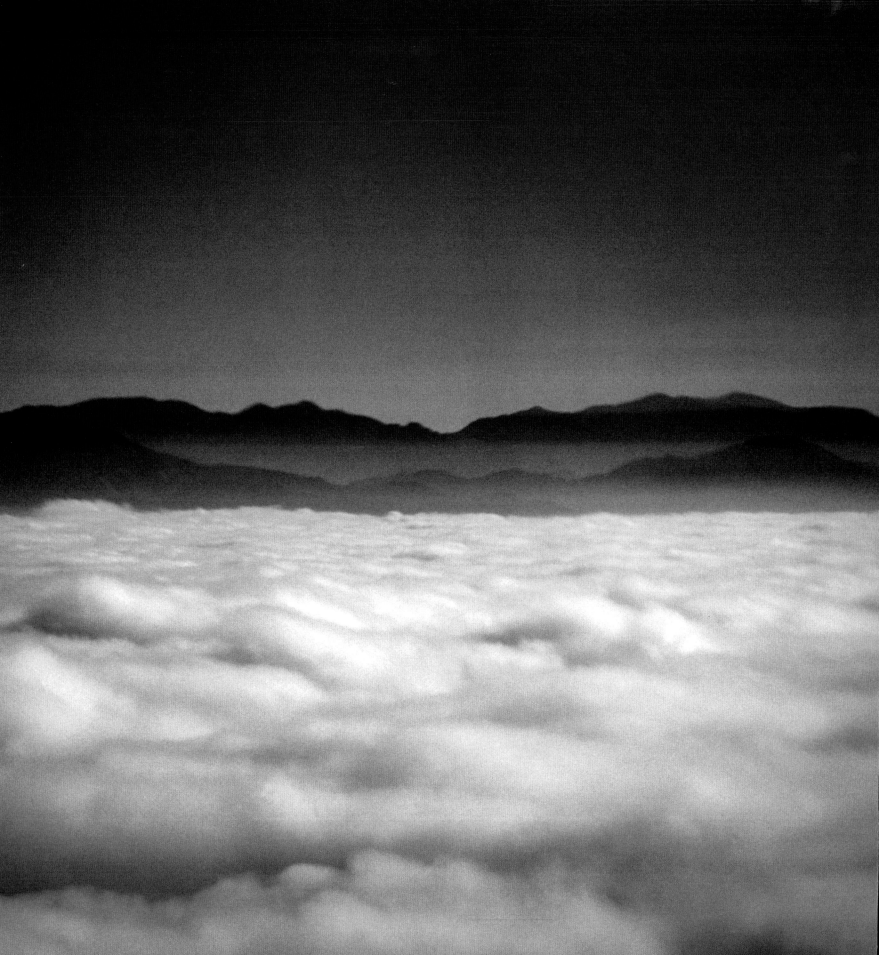

Editing

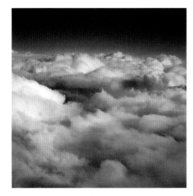

San Francisco to Dallas, 2001

To REVIEW AND SORT these images, I printed them small—about 4 x 6 inches—and laid them out on the dining room table so I could see all of them at once. The ultimate viewing size would of course have been at actual size, with infinite resolution, and without the airplane window as a frame, but 4 x 6 is what I had to work with.

Whenever I organized the images—as I did on a regular basis—I found individual images, pairs, and trios (which changed nearly every time I arranged them). I don't see the images in terms of actual time and place (such as, "this is a sunset, or sunrise, or whatever you call it at the North Pole"). I see color palettes and gradients. I tried once to convey perceptions of time, starting with dawn—cold, crisp, gentle, awakening—moving into daytime—bright mountains, green farmland, blue water glistening, light performing a circus act through 15,000 feet of cloud layers—and finishing with sunset—a perfect gradient of white, yellow, orange, red, purple, blue, deep blue, even deeper blue, and the darkest black you can imagine. This is almost like covering an entire day, but it doesn't work if you leave one place, fly for 14 hours, and arrive the same day somewhere else just two hours later. (Maybe I've just discovered another wrinkle: our assumptions about time expressed through the concepts of *morning, day,* and *night.*)

I enjoy the abstract photos the most; I chose to include them for their mood because they convey that it was actually 60° below outside even though it was sunny, or because they suggest how quiet it must have been in the fog. Others are so beautiful that when I shot them, I wanted to walk out on the wing of the plane to look all around. And then there are the images that stand out because when you really look at them, you lose all perspective of what the subject is and become completely entranced by the shapes and colors in the image itself.

Deciding which images to include here was difficult, to say the least. I have my favorites—and everyone who has seen the portfolio has had their own ideas about which photos are "must-haves." It's been very enlightening to hear such vastly different opinions. Finally it came down to the images I (and my editor) thought worked best, as individual images as well as part of the overall sequence.

81

San Jose to Los Angeles, 2001

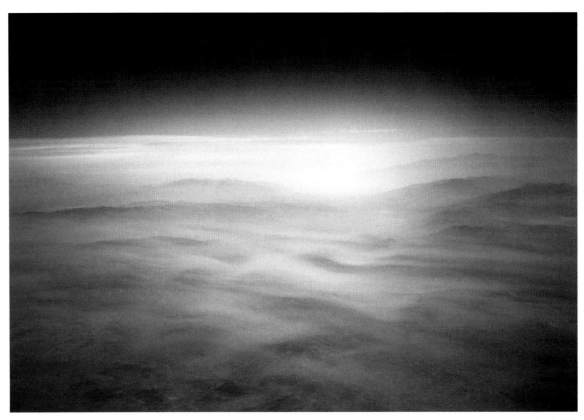

Denver to Missoula, 2002

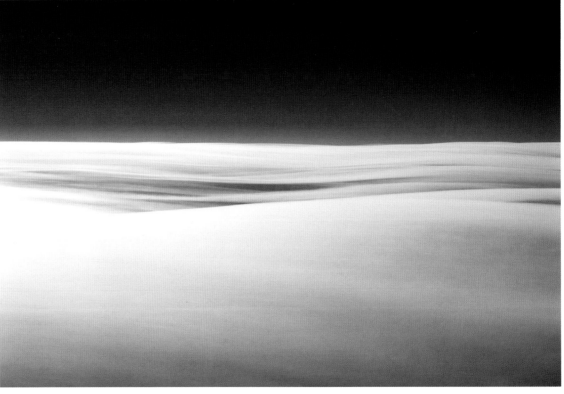

London to San Francisco, 2004

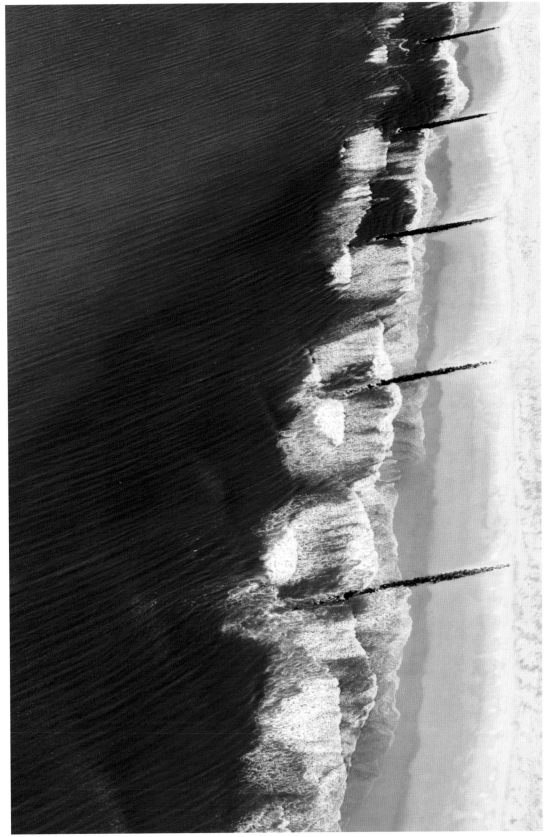

83

San Francisco to New York, 2004

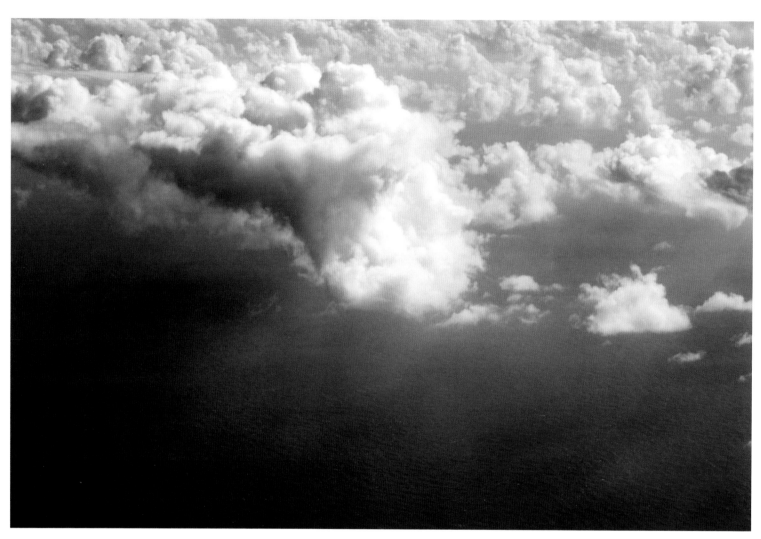

San Francisco to Chicago, 2000

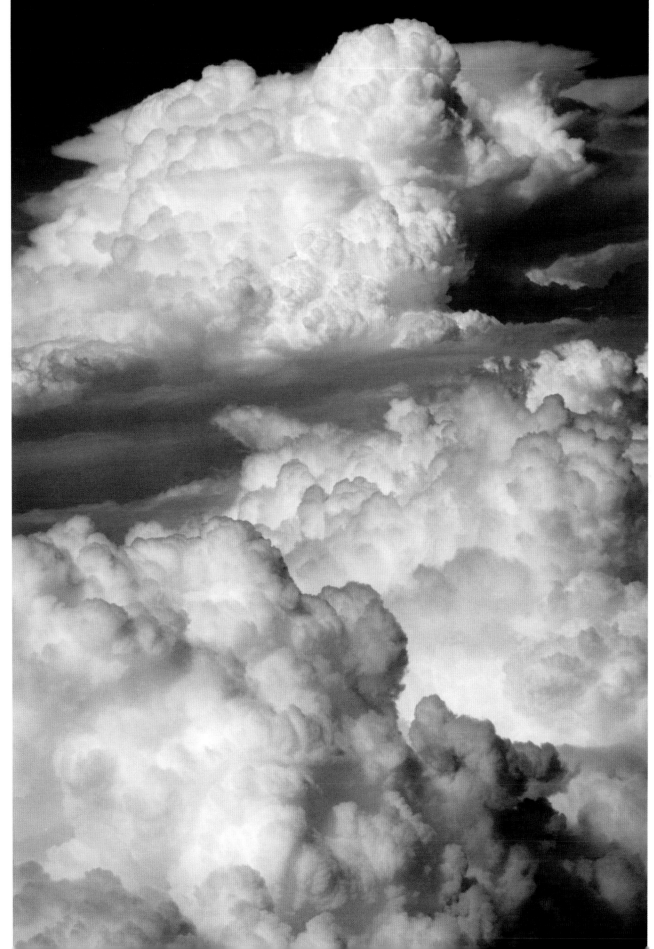

85

San Jose to Chicago, 2004

86

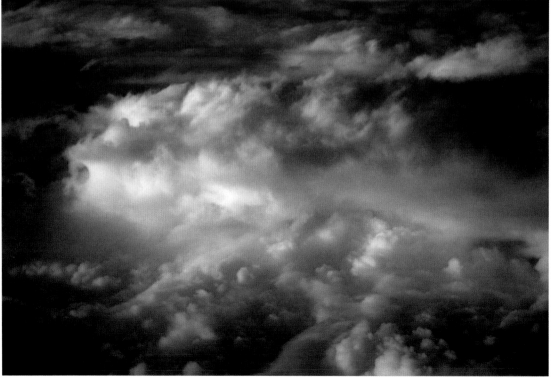

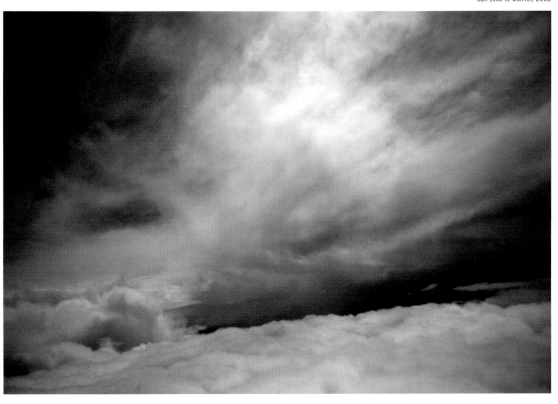

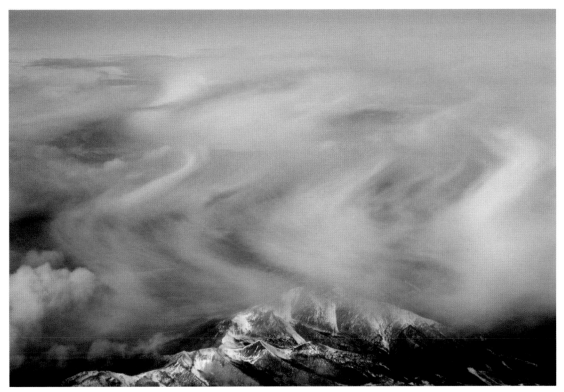

Miami to Denver, 2003

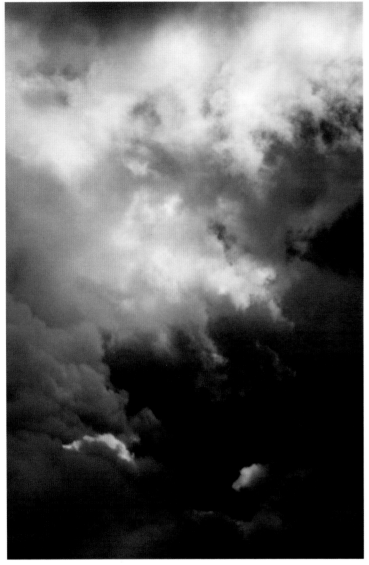

Tampa to Denver, 2005

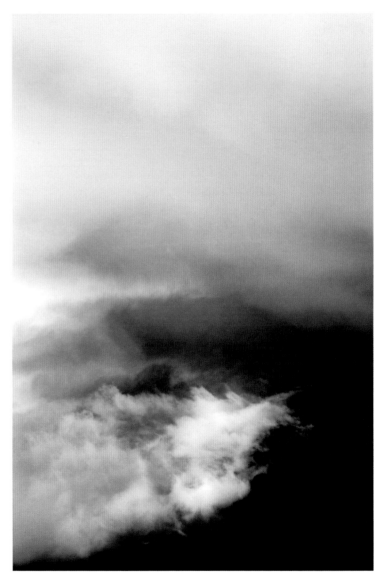

San Jose to Newark, 2005

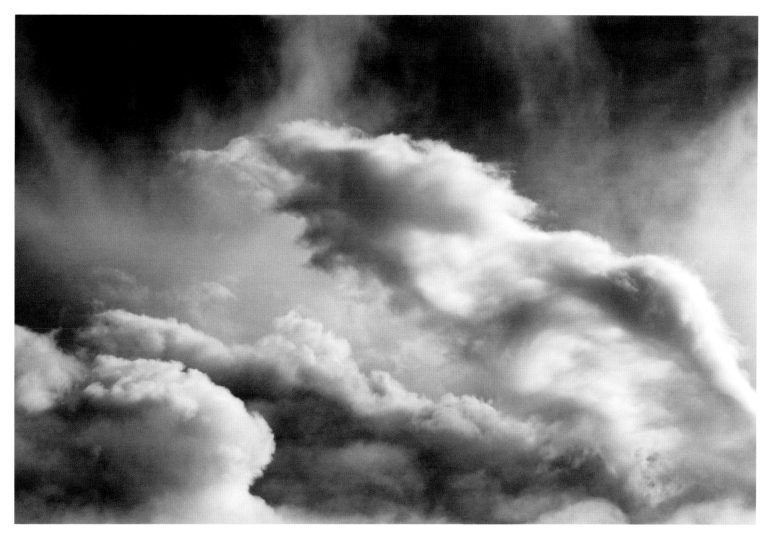

Tampa to Denver, 2005

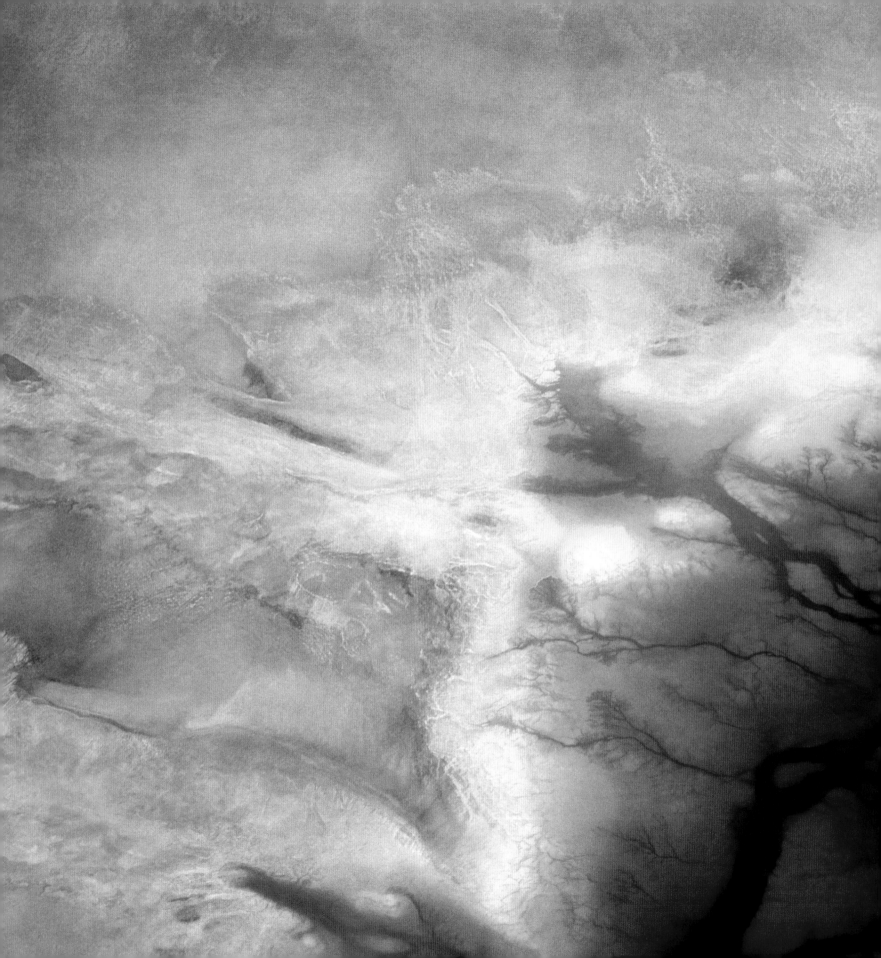

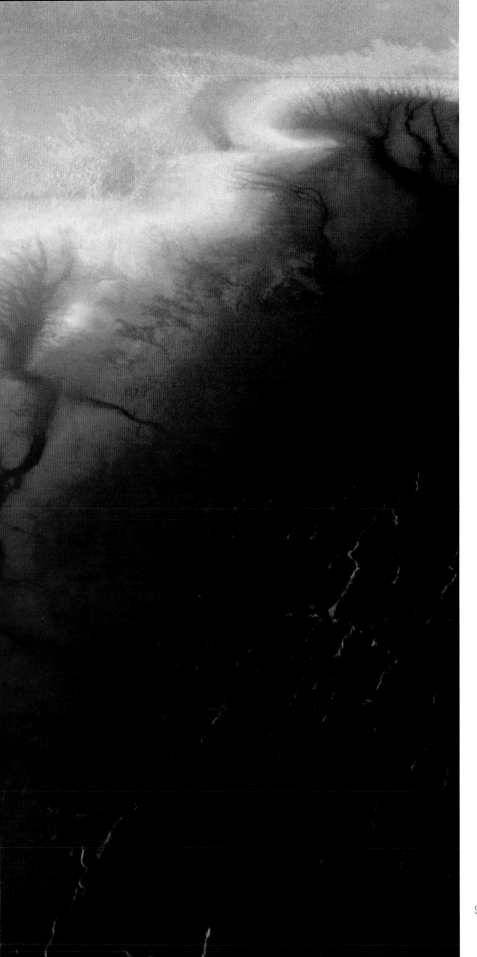

*…I wanted to walk out
on the wing of the plane
to look all around.*

San Jose to Chicago, 2005

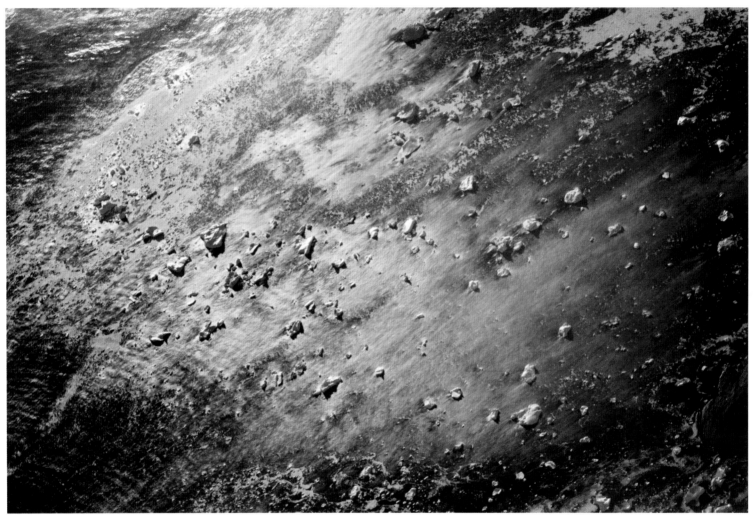

London to San Francisco, 2004

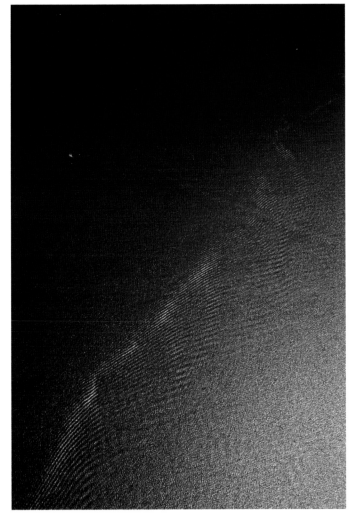

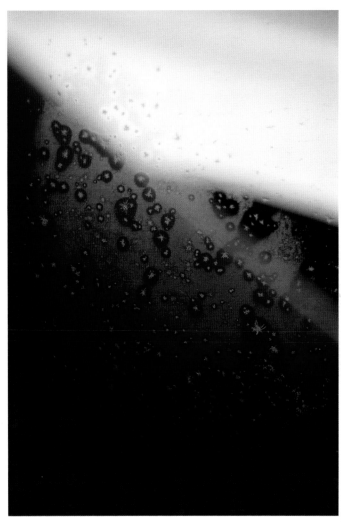

San Francisco to Honolulu, 2001

Frankfurt to San Francisco, 2002

93

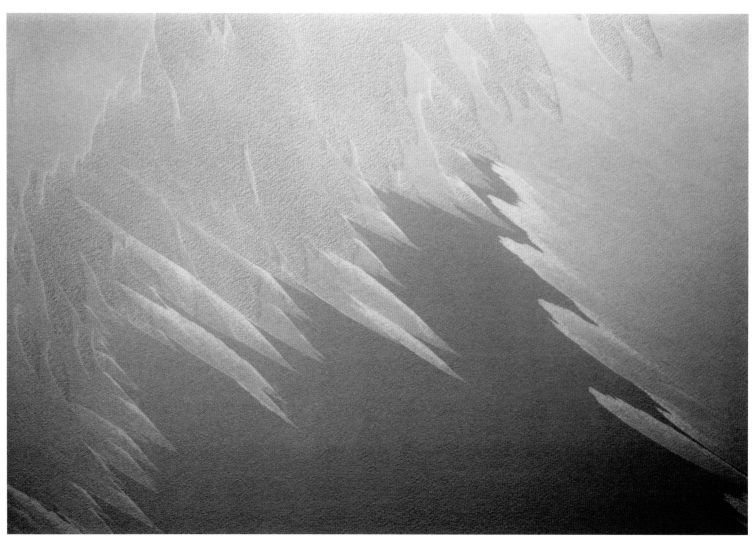

London to San Francisco, 2004

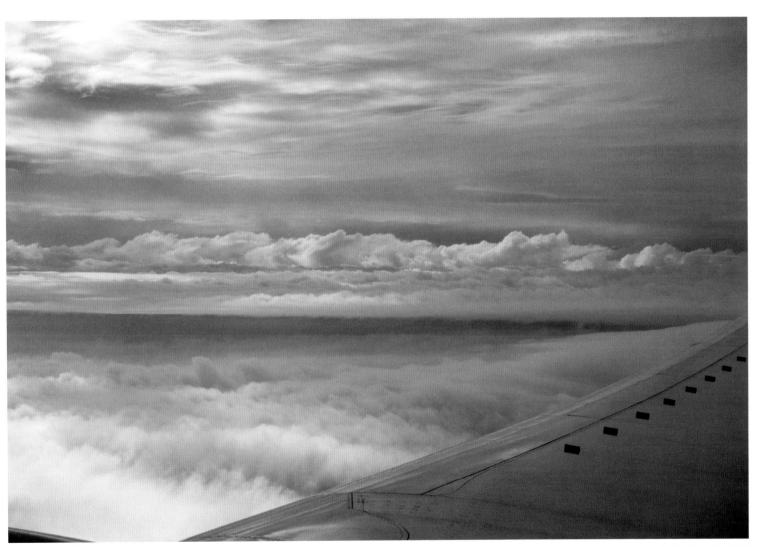

San Francisco to Miami, 2002

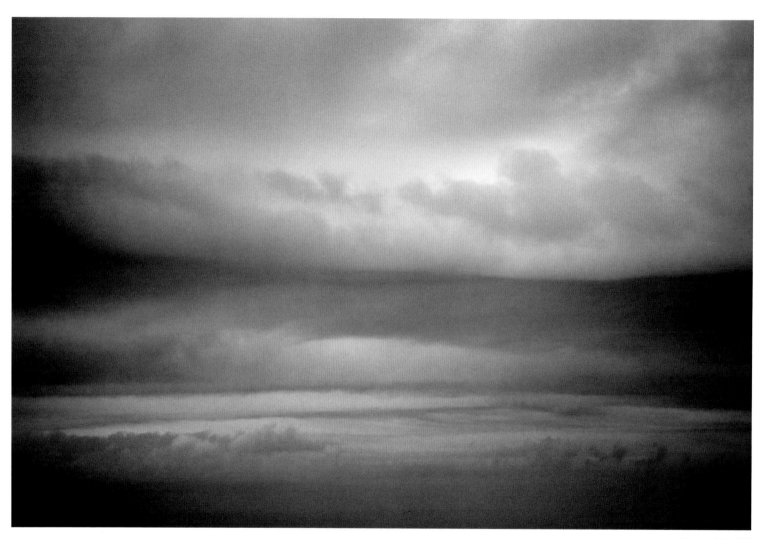

Chicago to Dallas, 2002

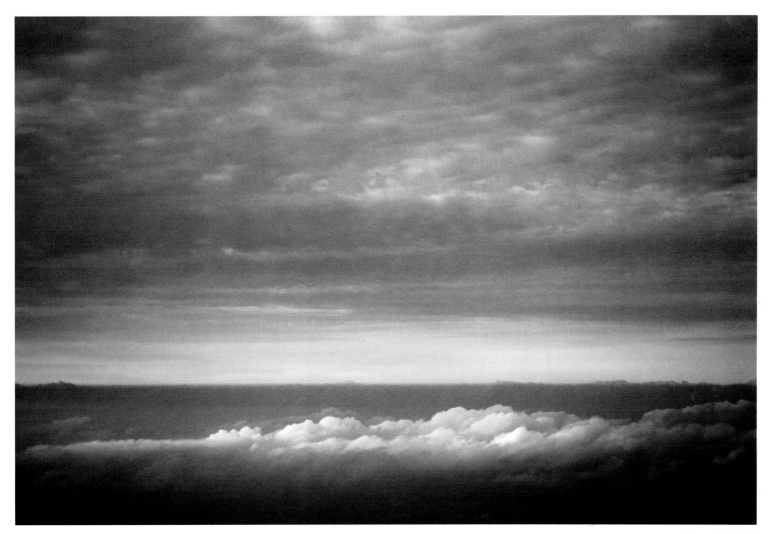

Chicago to Dallas, 2002

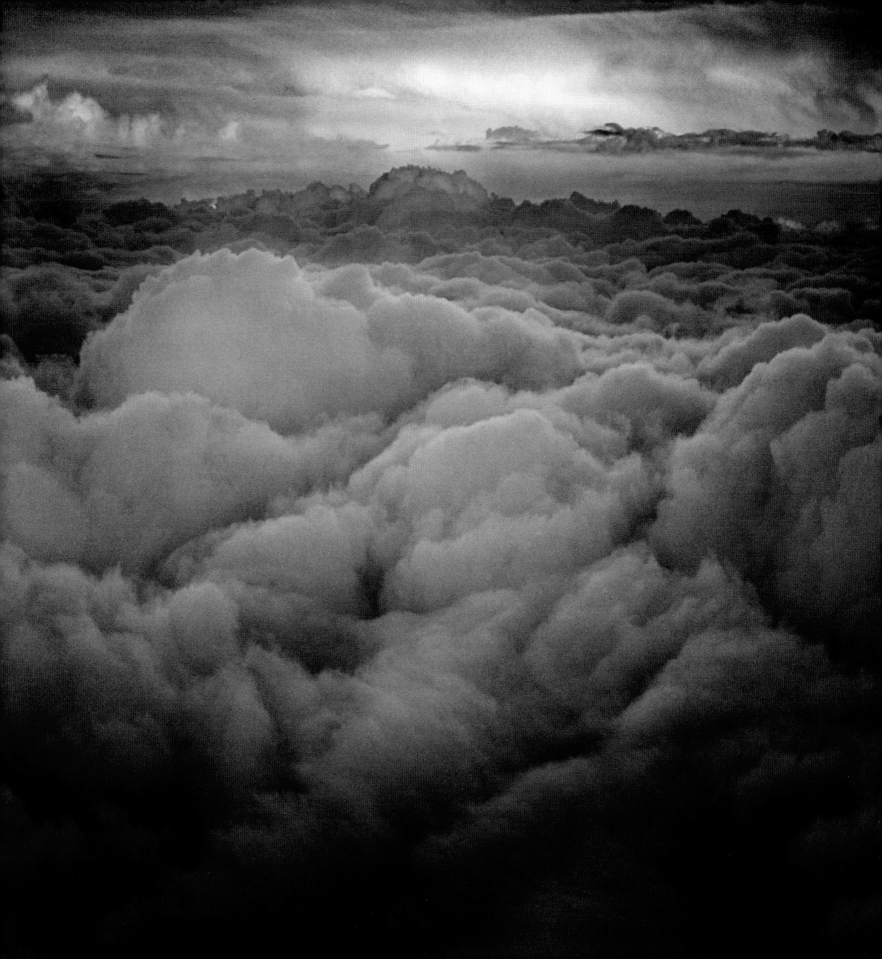

Image Manipulation

Denver to San Jose, 2002

When I scanned the photographs and brought them into Photoshop, I had no rules or limitations about how much or how little to manipulate them, although I chose not to move any objects or combine any images. My intent in adjusting these images was to relive what I felt when I was looking through that window, not to view what the camera, in its sometimes too-literal way, captured. If I pointed a camera out the window, it was because I was moved by something I saw.

Often, when I return home and see the raw images again on the computer, I don't think they convey what I saw or felt at the moment I shot them. Maybe the orange cast of the airplane's reading light made the scene outside seem that much bluer, or perhaps the dynamic range of the sunset just isn't properly represented in the image. After all, the camera is calibrated to neutralize light, not to capture emotion. I don't use Photoshop only to correct the image mechanically, but also to inject a sense of the passion I felt at the time the image was taken.

We are fortunate to be living at a time of such exciting and rapid developments in digital technologies, when image manipulation has progressed to a point that many people once thought impossible. I always try to look at the tools that are available to us as gifts: new technologies that allow us to expand our capabilities and explore new and meaningful ways to communicate with each other. Photoshop is one of those gifts; it offers an unlimited range of possibilities for manipulating image appearance: retouching to remove or add elements, making subtle or radical color adjustments, cropping to new aspect ratios and to remove unwanted information, and combining multiple files into one image, to name a few.

Denver to Tampa, 2002

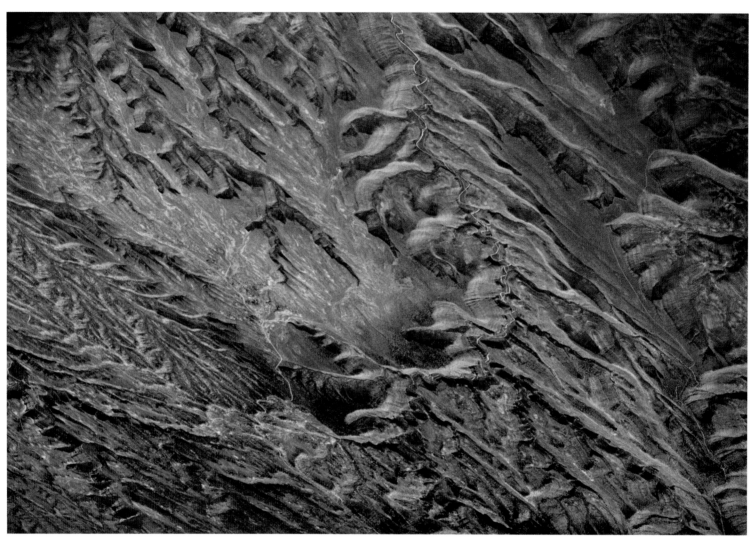

San Jose to Tampa, 2001

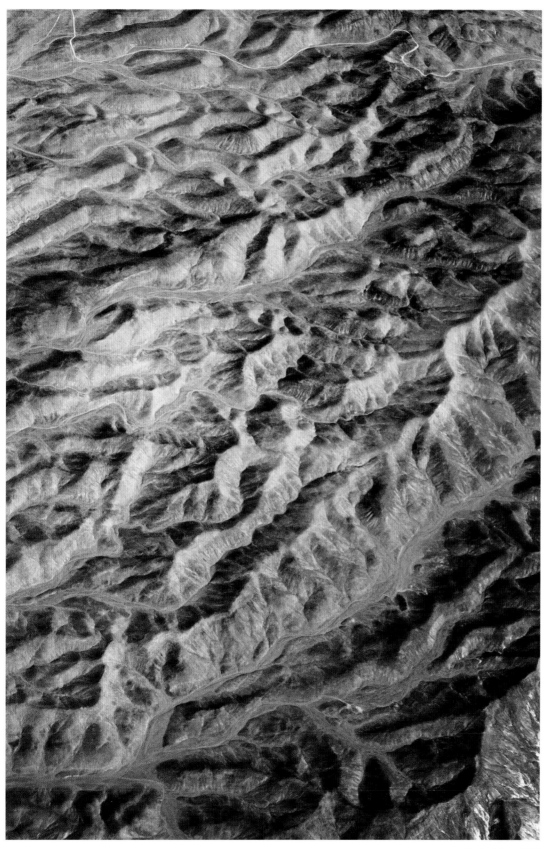

San Jose to Denver, 2004

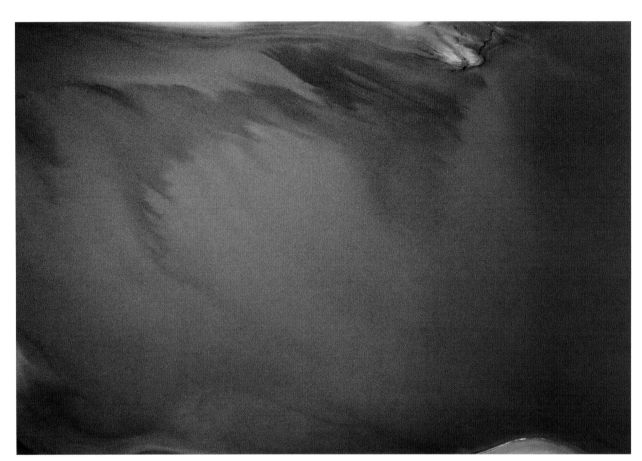

Los Angeles to San Jose, 2000

Denver to San Francisco, 2000

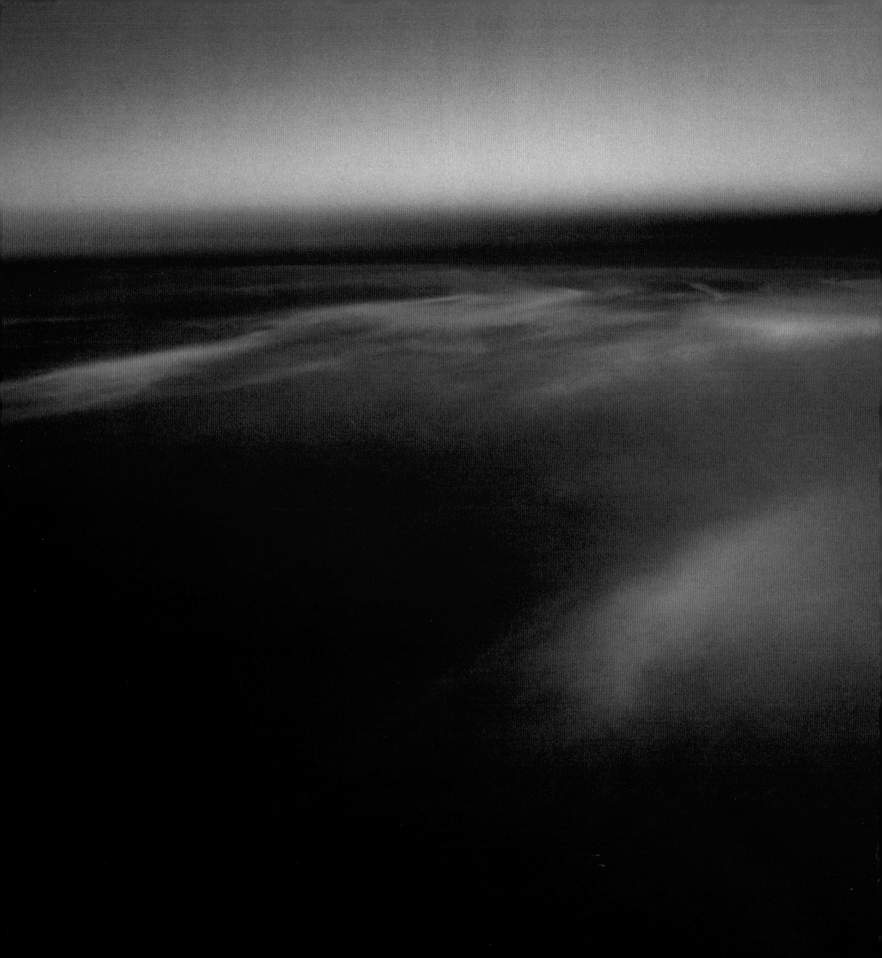

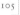

…the camera is calibrated to neutralize light, not to capture emotion.

Tampa to Chicago, 2002

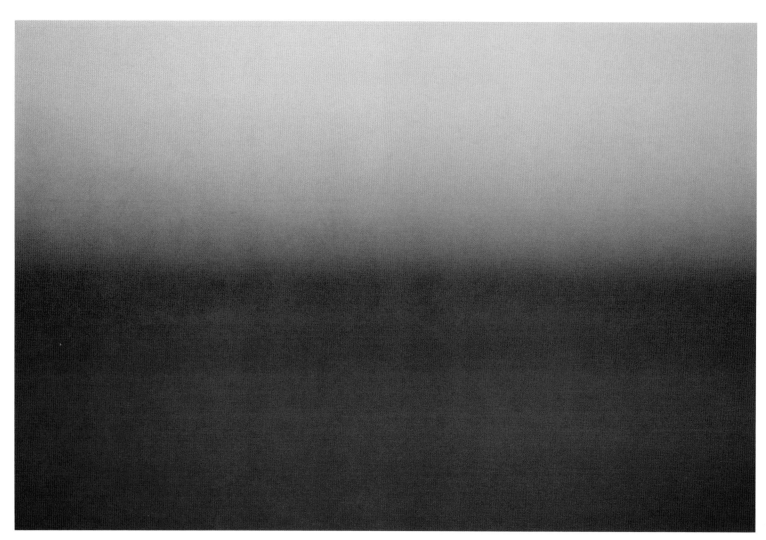

Chicago to Stockholm, 2005

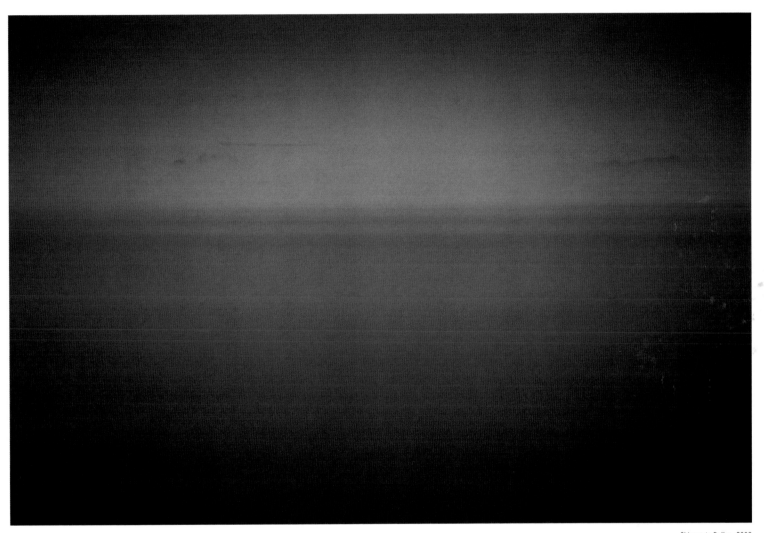

Chicago to Dallas, 2002

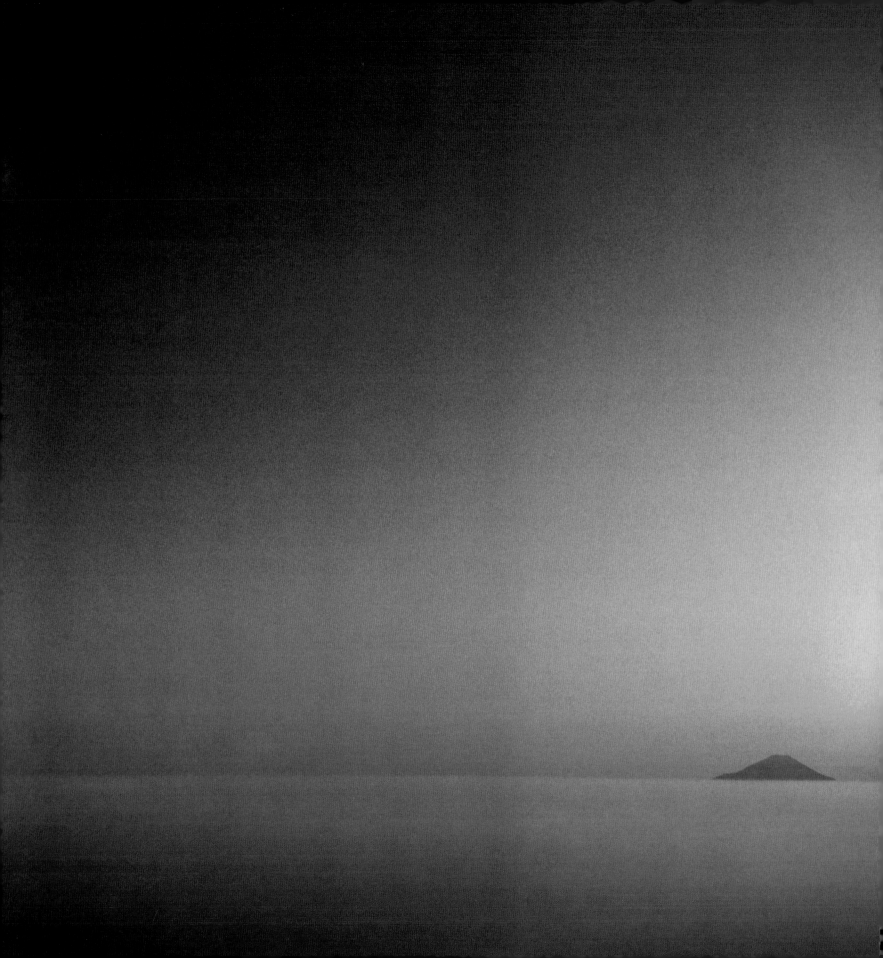

Completion

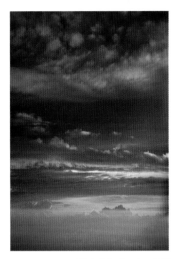

Atlanta to San Francisco, 2002

MORE THAN ANYTHING, completing this project has validated for me that the full execution of an idea is worthwhile. Many people have shot pictures through airplane windows, but, as with so many other creative ventures, few have chosen to focus on the subject passionately for five years or more. In that length of time, you develop an eye, a knack, a sense, and a craving for more. This craving is what keeps the process going.

When I started this project, the first images I shot were unrelated. Over time, however, I began to see trends among them; I knew I wanted to capture storm clouds and mountains, polar ice and fields of hay. I found that I also wanted to "round out" the collection to include what I thought were unique images. When I felt that I had a representative image for just about everything I had seen out of airplane windows over the last five years, I knew that the project was nearly complete.

At that point, I needed to draw a line in the sand and say, "This is it. This is what I want to share." A book is challenging because unlike a web site or a digital slide show, ink dries. You can't simply swap out images after the book is printed. Adding or deleting pages is a logistical nightmare; it's a finite deadline in both time and content. On the other hand, a book serves to not only convey the images, but also to make them into things: physical, tangible, textural. They can be pondered in the comfort of an easy chair (or a window seat, for that matter), rather than on a computer monitor or television.

Part of me wishes that the project could go on forever. I know there will be images I've yet to shoot that I'll wish had been in this book, but it's not worth the tradeoff to wait for them. The view out the window is all too familiar now, and unique images will be harder and harder to come by. So, while I'm looking forward to seeing those images I have not yet taken, I also know that it's time for me to publish these. To progress as an artist, I need to share my work and open myself up to praise and/or criticism. And after all, if I don't set some parameters for myself, how will I ever know when I'm done?

109

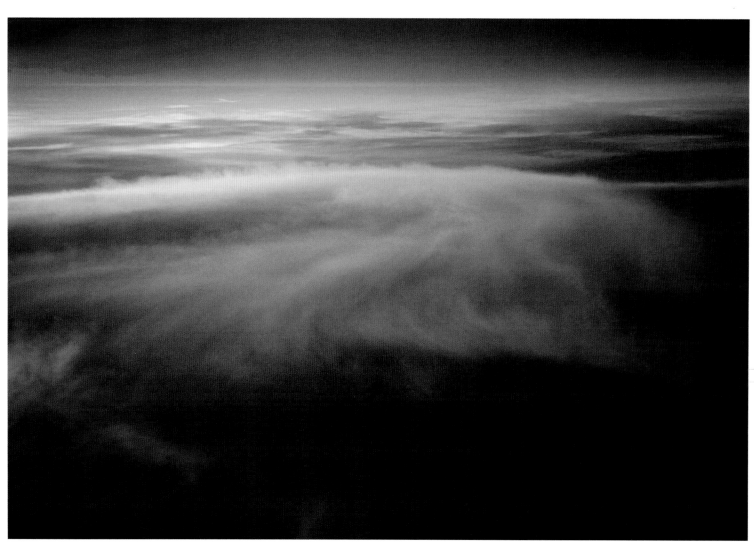

Atlanta to San Francisco, 2002

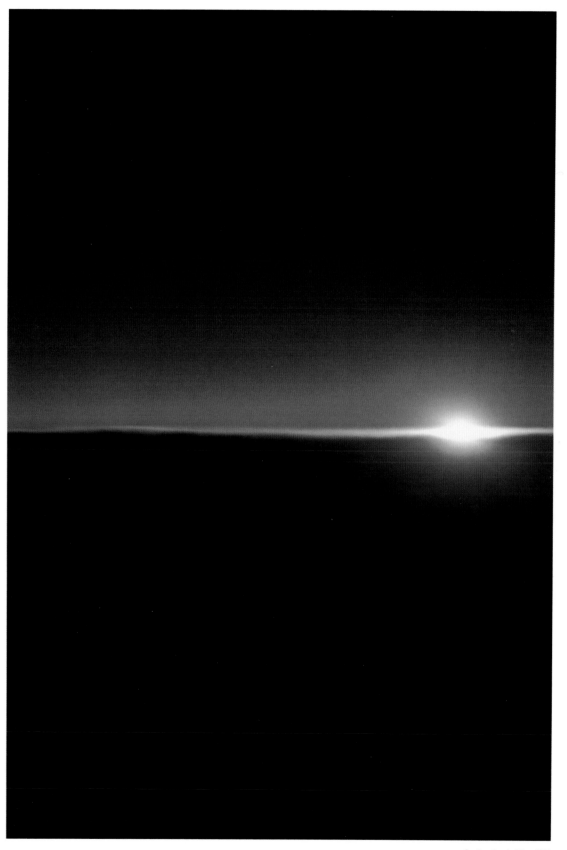

San Francisco to Tokyo, 2001

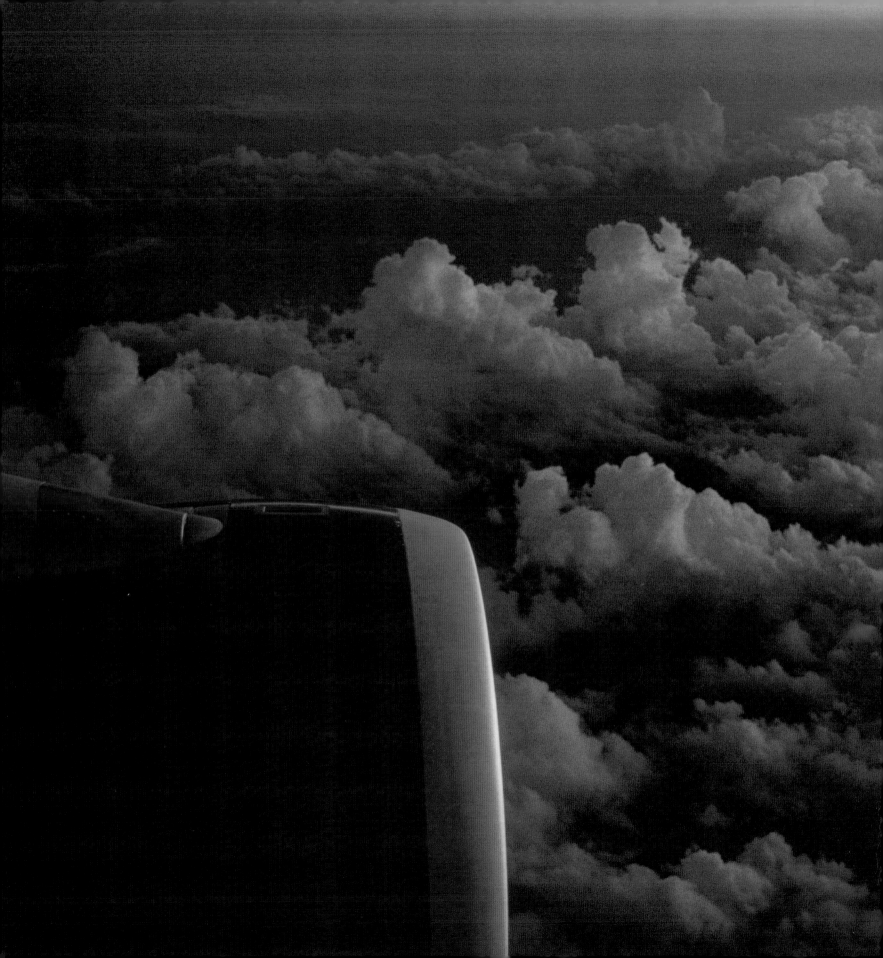

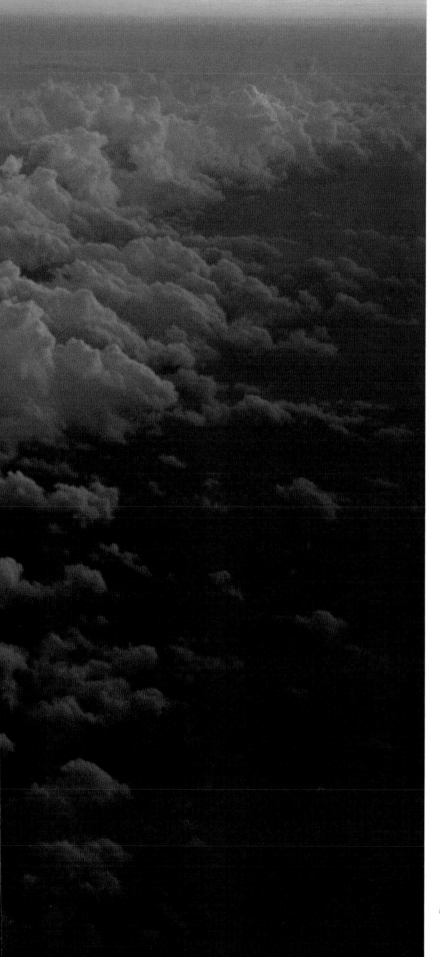

More than anything, completing this project has validated for me that the full execution of an idea is worthwhile.

Atlanta to San Francisco, 2002

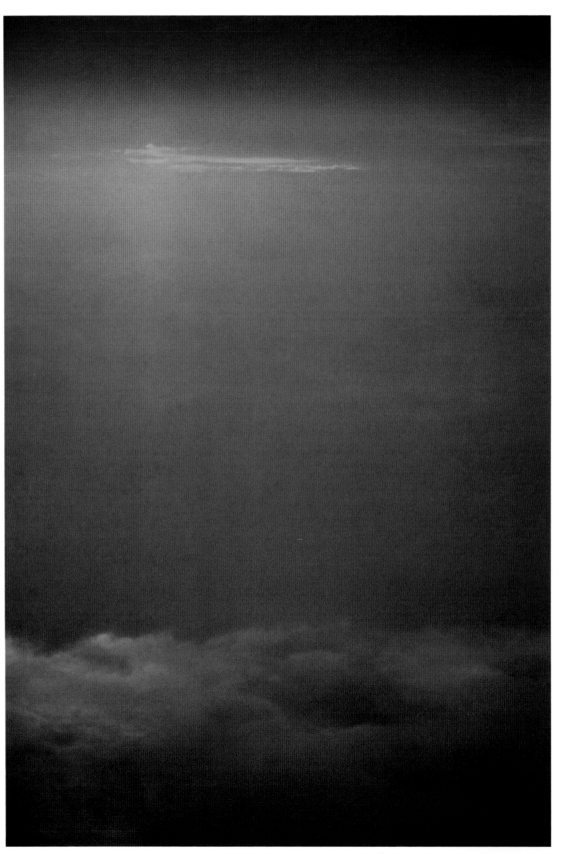

114

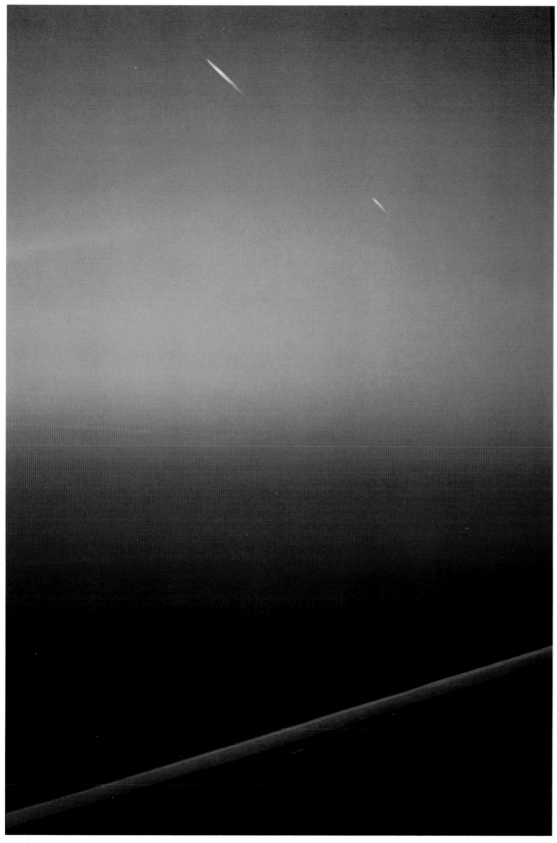

Miami to New York, 2002

Denver to Atlanta, 2002

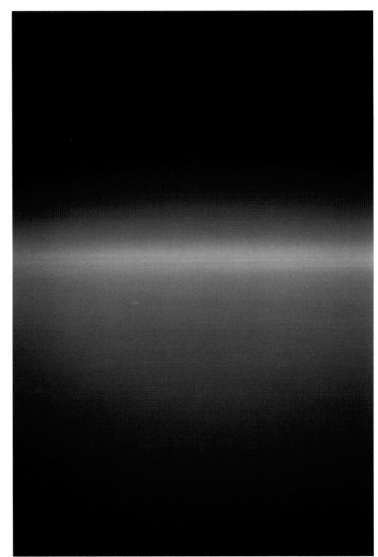

San Jose to Tampa, 2002

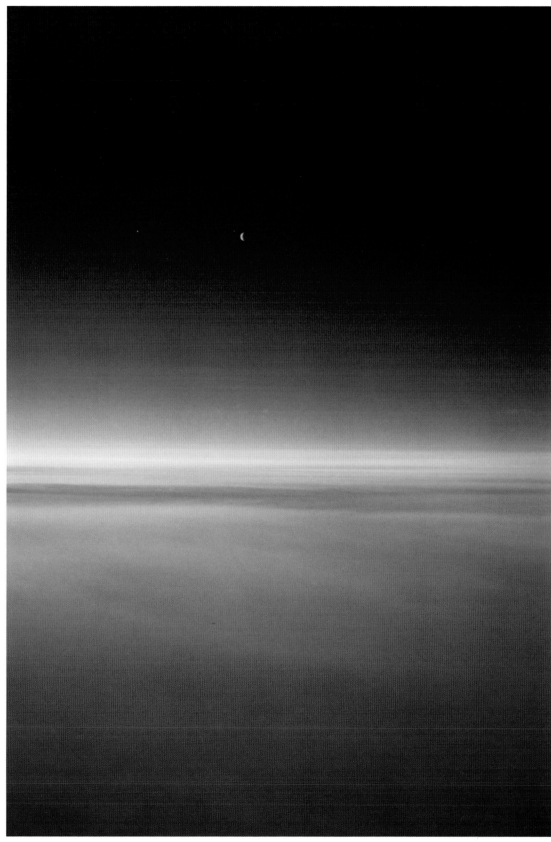

Frankfurt to San Francisco, 2001

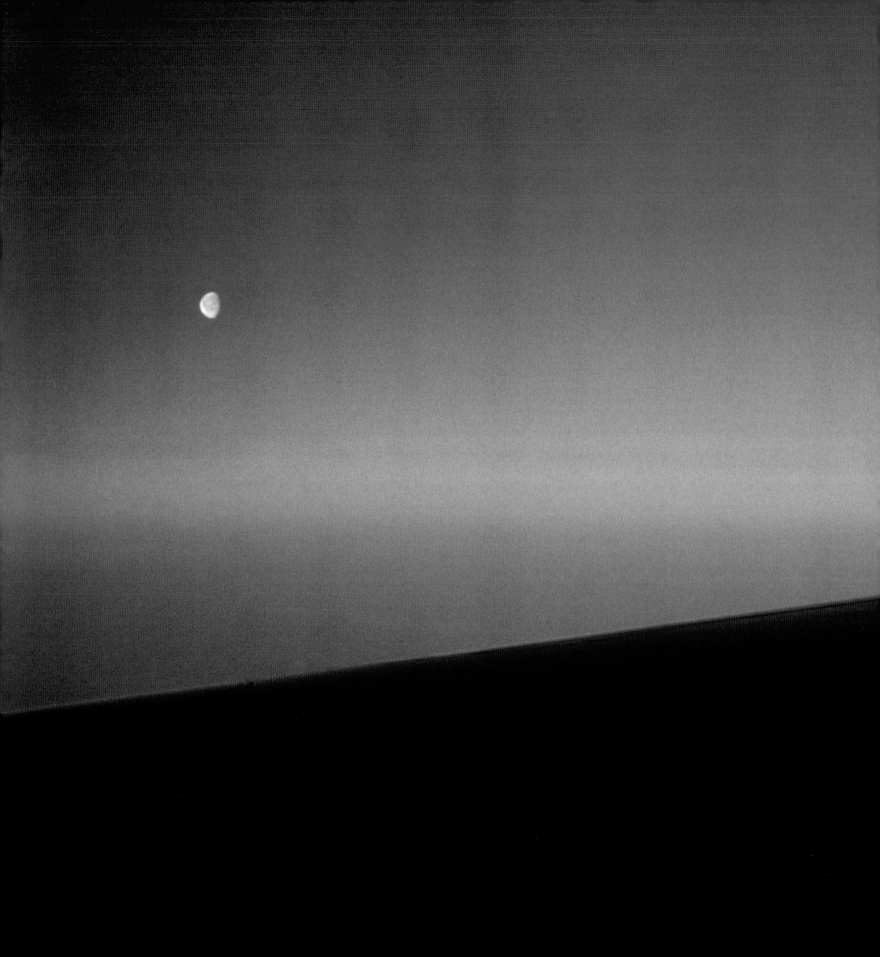

…if I don't set some parameters for myself, how will I ever know when I'm done?

Frankfurt to San Francisco, 2002

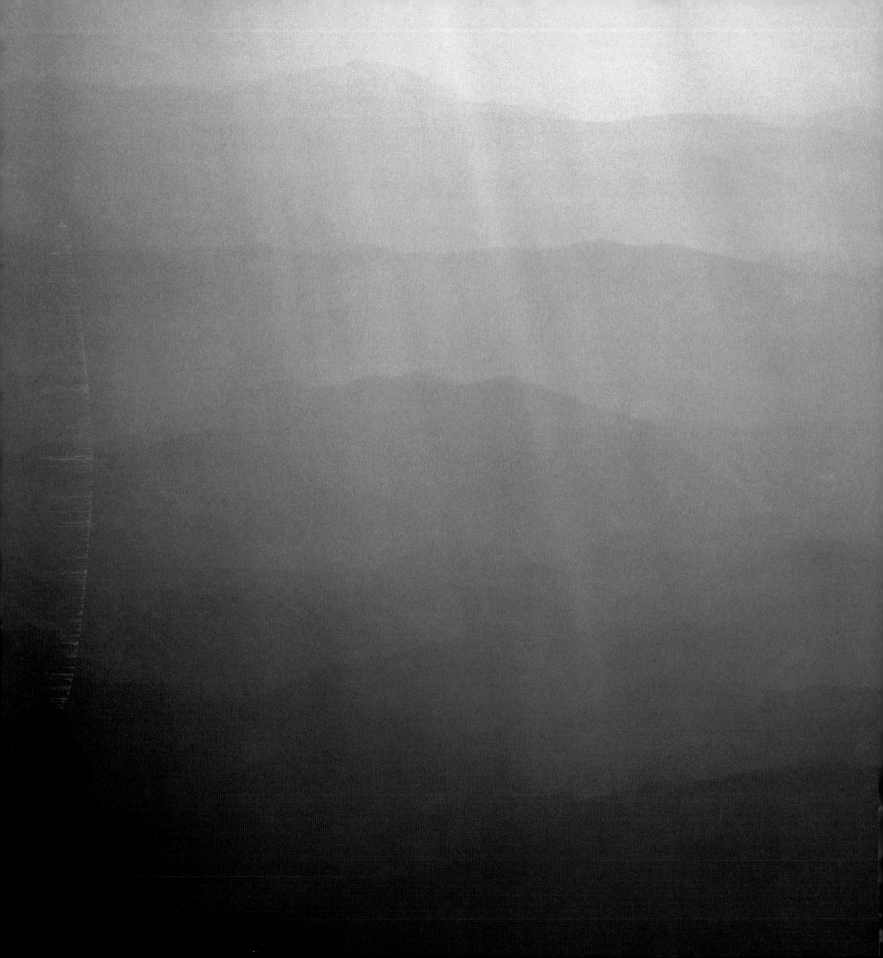

APPENDIX

Denver to Missoula, 2001

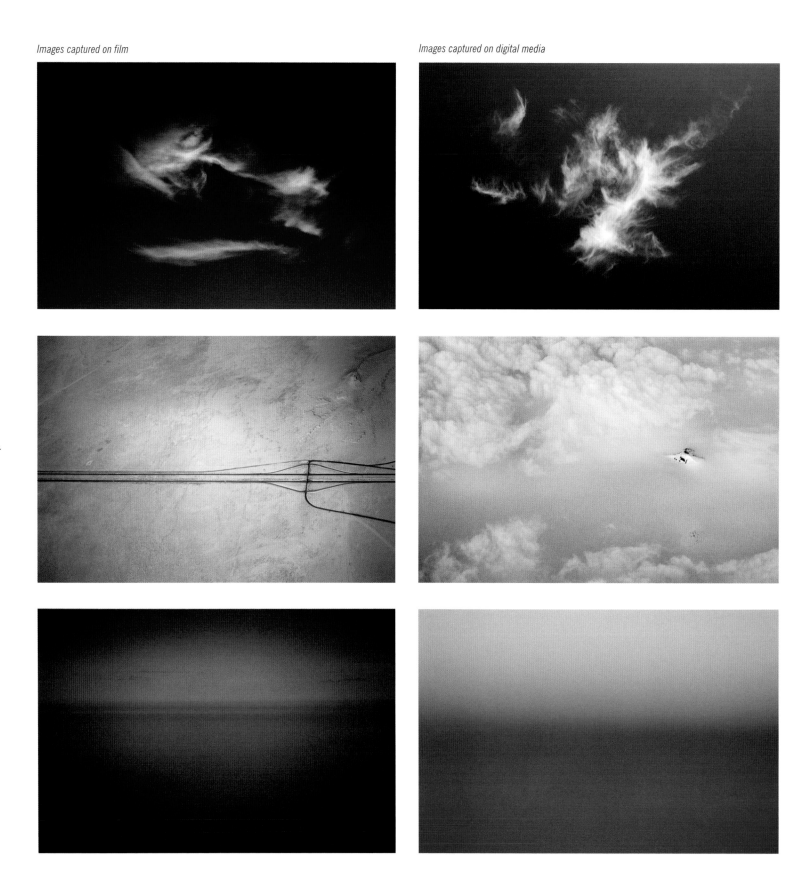

Capturing Images

At the beginning of this project, I was shooting film using my Nikon N90s with a 28-70mm lens. All of the images were captured using Fujichrome Velvia (ISO 50) daylight film. Each image was then scanned on the Imacon Flextight Precision at the highest settings (approximately 7650 × 5200 pixels) at 16-bit, creating a 227MB image file.

During the project, I began transitioning to digital capture with a Nikon D100, using a 35-70mm lens. The ISO was set to 200 (the lowest setting for the D100) and the white balance to either Automatic or Cloudy. I shot using Nikon's RAW format to capture the largest amount of information, which gave me the flexibility to process the images multiple times using different settings if I later chose to. When possible, I tried to open the aperture (while using either camera) as far as I could. This allowed more light into the camera as I focused on the clouds or landscape, avoiding scratches or ice on the multilayer windowpane. All of the digital images were processed using Adobe Camera Raw in either Photoshop CS or Photoshop CS2 and were brought into Photoshop at 2000 × 3008 pixels (the native capture size) in 16-bit.

I used a combination of Lexar and SanDisk media; I count myself lucky that to date I have had no problems with either media. The only mishap was my own fault when I inadvertently left my entire pack of CF cards on the plane! Luckily, I had written my name and phone number on each card (which is a very good idea). The gracious person who found them turned them in to the airline, which then returned them to me.

One of the constant difficulties of shooting through the window was reflections—light sources behind me, my watch, my sleeve, my book, and even my camera. When I began the project, it was easy to cover both the window and myself with a black fleece or jacket. After 9/11, I became more anxious about doing anything that looked suspicious. I have since learned to position myself to avoid reflections. I also try to book the "shady side" of the plane so that I avoid shooting into the sun and can steer clear of lens flare as much as possible. I have not found polarizing filters to be advantageous, as most airplane windows have a coating that reacts with the polarization and produces an artificial rainbow of colors.

The most frustrating times are when I'm unable to get a window seat and can see beautiful landscapes and clouds from the aisle or middle seat, but can't photograph them. And, of course, there are the flights where I sit on the "wrong" side, or over the wing, which blocks my view, or behind the engines so that the exhaust prevents me from photographing with any clarity—all equally annoying missed opportunities.

123

About Computers, Monitors, and Peripherals

I am equally proficient in Macintosh and Windows environments and use both, since Adobe Photoshop is essentially the same from a user standpoint. I have a LaCie Electron 22 Blue IV monitor, as well as a Sony Artisan. I have been extremely successful calibrating my monitor and making printer profiles with X-rite and GretagMacbeth hardware and software solutions. And I can't even imagine working without my Wacom tablet —it is indispensable when it comes to dodging and burning, selecting, and masking techniques.

File Management

I do my best to maintain a structured workflow so I don't have to concentrate on the technical details of my process. That way I can spend more energy recreating the image I remember instead of trying to locate a file or figure out on what flight it was taken. When manipulating images scanned from film, my workflow differs only slightly from working with images I shoot digitally.

When I was shooting film exclusively, I kept a folder on my desktop computer called "New Scans," and whenever I scanned an image, I placed it into this folder. When the folder reached a certain size, I burned the original scans to CD or DVD. If I wanted to work on one of the images, I would put a copy of it into a "Working Folder" and make my changes to the duplicate image. This prevented me from accidentally saving over the original scan.

Now, when shooting digitally, I keep a folder on my computer called "New Photos." As soon as I fill a compact flash card or finish a flight, I create a new folder titled with the flight origin, destination, and date (SFO_ORD_06_2005), and then copy the files from the card to that folder.

Using Adobe Bridge, I navigate to this newly created folder and let Bridge create the necessary thumbnails. I have the cache preference in Bridge set to Use Distributed Cache Files When Possible, so that I can move images around freely on my hard drive (or within Bridge) without losing this cached information. This also prevents me from having to remember to export a cache manually when I want to archive the images to a DVD.

I do a quick edit using the Slide Show feature in Bridge and trash the really poor images, which, for me, include those with obvious technical flaws, such as bad exposure, too much reflection, part of the surrounding window, or images with aesthetically poor composition. If I see any really stellar images, I label them with five stars (a feature of Bridge) so I can find them quickly with the Find command.

When I finish this quick edit, I take the time to rename the images. Just as I have a naming convention for folders, I have one for images, too. For this project, I used the Batch Rename feature in Bridge to rename the images with the flight origin, destination, date, and sequence number. Then I used File Info to embed my name, contact information, and copyright—I marked the Copyright Status as Copyrighted in all of the images. (This is an easy process if you take advantage of metadata templates.) In some cases, I also added keywords to make image searches easier.

I monitor this "New Photos" folder constantly and back it up to DVD when it reaches 4+ gigabytes. Instead of splitting a flight into two folders on two DVDs, I prefer to put an entire flight's images on one DVD, even if that leaves some empty space. To be on the safe side, I also back up the images to another hard drive which I keep online and accessible at all times. Having the images available online is much faster than searching multiple archived CDs or DVDs when I'm looking for a specific image.

About Caches in Adobe Bridge

Adobe Bridge stores thumbnails and other information about your files in a separate file called a "cache." This allows thumbnails to be created once and then simply reused from the cached information. Under Preferences → Advanced, you may choose to work with one centralized cache file (set by default) that will save your files to a centralized cache location, or you can select Use Distributed Cache Files When Possible, which will save cache files in individually browsed folders. The reason for the phrase "When Possible" is because Photoshop may not be able to write to the media you're browsing, such as a mounted file server for which you don't have write privileges or a CD or DVD that has already been recorded.

If you use the option to Use Distributed Cache Files When Possible, you won't have to worry about exporting your cache (when burning CDs or DVDs, for example) or moving folders on the hard drive (as opposed to moving them from within Bridge). However, it will cause Bridge to create cache files in every folder to which you navigate, even if there are no images in the folder. To view the cache files, select View → Show Hidden Files.

125

Before processing

After processing

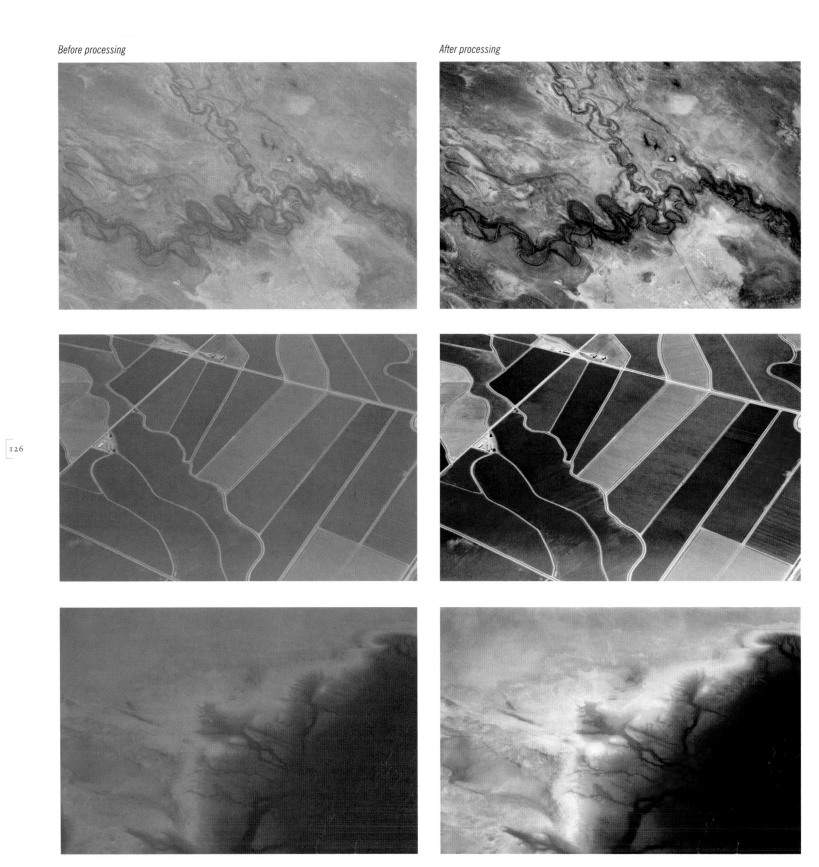

Processing Using Adobe Camera Raw

I like to think of processing the files in Adobe Camera Raw as analogous to processing traditional film; however, there are many advantages to working digitally. For example, you can process a file multiple times with different instructions and then composite the images to create an ideal negative. When processing digital camera captures, the main advantages Photoshop CS2's Adobe Camera Raw offers are control and flexibility—it can correct individual images and also batch processes multiple raw files. By capturing images in the camera's raw format, I can change the settings for processing the files without permanently changing the original images.

As you can see from the pre- and post-processed images on the previous page, the raw images captured at 30,000 feet through airplane windows need a significant amount of adjustment. Their dynamic range is uncharacteristically narrow, their appearance dull, dreary, and uninteresting. I begin by selecting the file (or files) that I want to process in Bridge and choosing File → Open in Camera Raw. Then I adjust the white balance and exposure of the first image. To eliminate any unwanted color casts, I use the White Balance tool to click on an area of the image that should be neutral. If there weren't any neutral areas in original scene, I use the Temperature and Tint sliders to visually correct the white balance.

I find the Auto Adjustments provide a good starting point, so I leave them all turned on in the Adjustments panel and refine the image from there. If necessary, I use the Exposure and Shadows sliders to set the black and white points of the image, thereby extending its dynamic range. I monitor these changes with the histogram preview and clipping warnings for highlights and shadows. Sometimes, as a result of making such dramatic changes to the dynamic range, the white balance requires a slight readjustment; I use the White Balance tool or the Temperature and Tint sliders to fine-tune it.

If the midtones require additional adjustment, I use the Brightness and Contrast sliders in the Adjust panel, or I modify the Tone Curve in the Curve panel. The Brightness slider is similar to using the gray gamma midpoint slider in Levels (in Photoshop); the Contrast slider is similar to adding contrast using an s-curve in Curves. For optimum control, I prefer to use a tone curve. In the Tone Curve panel, I can choose from a list of curves or modify an existing one. When I create a custom tone curve that I may use again on similar images, I save it by selecting Save Setting Subset from the Settings fly-out menu and choosing Tone Curve. (After you name and save the tone curve, it will automatically appear in the Tone Curve pull-down.)

In the Details panel, I turn off sharpening by setting the slider to zero; I prefer to sharpen my images in Photoshop CS2 (using Unsharp Mask or Smart Sharpen) so that I can sharpen explicitly for the printer, inks, and paper that I plan to use. Because these images required such dramatic adjustments, any noise that appeared in the images was amplified. Since these images were already a little soft by virtue of the subject matter, increasing the Luminance Smoothing to 25 (to remove noise in the gray values) and the Color Noise Reduction slider to 50 removed the noise without significant loss of detail. On occasion, I also use the Lens panel to add a subtle vignette to an image by slightly darkening the edges.

After making adjustments to one image, I can apply some or all of those settings to other raw files. If I initially opened multiple images into Adobe Camera Raw, I Ctrl (Mac)/Cmd (Win)-click the thumbnails of the other open images and click the Synchronize button to display the Synchronize dialog. There I select the desired set of attributes to apply, either using the pull-down menu or by checking the boxes next to the attributes. (Note: To apply settings from one image to another without opening multiple images into Adobe Camera Raw, in Bridge select Edit → Apply Camera Raw Settings to copy and paste some or all of one image's settings to other images. You can also edit settings with this menu.)

After making all of my adjustments, I set the Workflow Options to open the files into the Adobe RGB (1998) working space (the space in which I characteristically work) in 16-bit. I usually open them at their native capture size, but if I know I'll be printing an image larger than the native capture size, I resample the image up using the Camera Raw size options. If, on the other hand, I'm not sure whether I will need to print the image at a larger size, I open it at its native size. This avoids resampling the image up and then down unnecessarily and allows me to work more quickly because it's a smaller file. After finalizing the settings and the Workflow Options, I may open the files in Photoshop, save them in another format, or select Done to apply the new processing settings to the files.

Original image with aspect ratio of 1:1.5 (showing crop for final image)

Final image with aspect ratio of 1:1

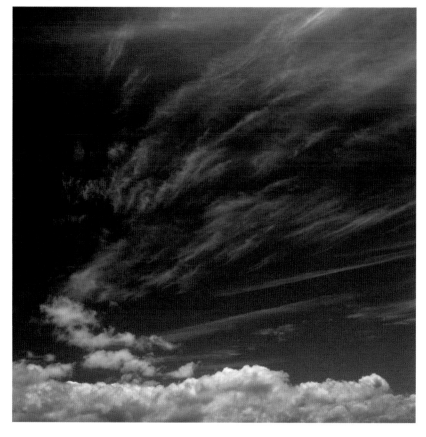

Panoramic image with aspect ratio of 1:2

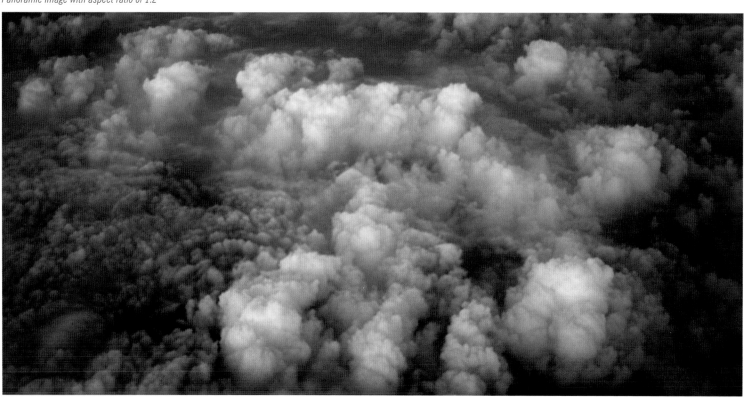

Original image with aspect ratio of 1.5:1

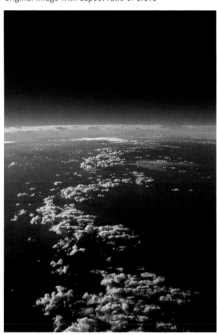

Image Size and Cropping

In this project, cropping images was the exception rather than the rule. When I was capturing the images, my goal was to fill the frame as fully as possible, which would yield the largest possible amount of information. This is especially important to do when the image will be enlarged, since details in both film and digital camera images appear to lose definition as they get bigger.

However, sometimes I find that the entire frame isn't necessary for creating the desired effect. Cropping can eliminate unnecessary or irrelevant information, thereby improving the final image. At other times, the aspect ratio of the capture device doesn't match the framing that I have in mind for the photograph. I might compose an image that is square or panoramic, yet be limited to capturing the image with a 35mm camera. In this case, I capture the image, knowing that I will crop off the "extra" information later. There are also technical reasons for not using the entire frame—for example, a wide angle lens might darken the corners, obscuring detail, or maybe there is something unavoidable in the frame, like the wing of a plane, that I will decide to remove.

In my opinion, cropping is neither right nor wrong—it's a personal choice, your decision. If you're in a studio and have control over lighting, the subject, and other necessary factors, then by all means, compose the image full-frame so that you have the largest amount of information to work with. But if you're on location with no control, trying to contort yourself into position to capture a scene that is moving by

at 500 miles per hour, don't miss the shot just because the wing is taking up an eighth of the image—you can crop it out later. And, if cropping an image (converting it into a panorama, for instance) focuses the viewer's attention on what is important, then go ahead and remove that extraneous information.

For consistency, I try to limit the number of different aspect ratios (crops) that I work with in a single project, but, in the end, I go with what feels right. In this project, I edited the full-frame digital images at the native capture size: 2000 × 3008 pixels (10.027 × 6.667 @ 300 pixels per inch). I scanned full-frame film originals at 7500 × 5100 pixels (25 × 17 @ 300 pixels per inch). Regardless of their capture formats, I cropped panoramas to an aspect ratio of 1:2, and square images, obviously, to 1:1.

In Photoshop, with the Crop tool selected, I entered the crop parameters in the options bar. Then, knowing I would be using those values repeatedly throughout the project, I saved them as Tool presets so that I could quickly toggle between them.

129

Unretouched image　　　　　　*Retouched image*

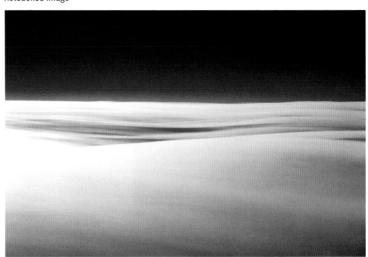

There was some lens flare in the upper left corner of this image. After the adjustment was applied, the flare completely disappeared and the sky color and texture is now consistent across the entire image. I also used a Hue/Saturation adjustment to intensify the colors.

Unretouched image　　　　　　*Retouched image*

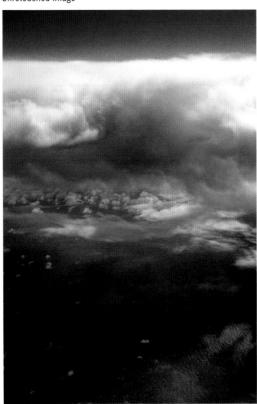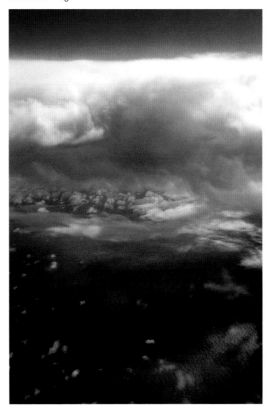

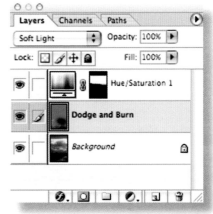

This image suffered from a reflection from the window. I used a series of adjustment layers to improve the image: note how much more detail you can see in the adjusted image, particularly the underside of the cloud and the surface of the water below. A Hue/Saturation adjustment layer was added to neutralize the cyan cast of the cloud.

Unretouched image

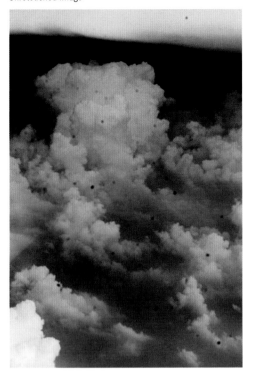

Retouched image

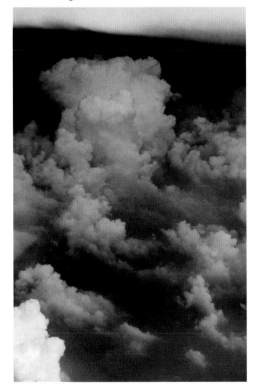

This image was covered with dust specks in places with many different textures and tonal ranges. I used the Healing Brush to remove them.

Removing Imperfections

Once I've decided that an image is worth keeping, I begin by removing any dust, scratches, or other imperfections. In order to see every pixel in the image (which allows me to be as accurate as possible), I double-click the Zoom tool to zoom to 100%. I then enter full screen mode by clicking the full screen mode icon near the bottom of the Photoshop toolbar or by tapping the F key. This hides any other open images (as well as the desktop if you're working on a Macintosh). Next, I tap the Home key to navigate to the upper left corner of the document.

My tool of choice for removing imperfections is the Healing Brush. To set the source point from which to copy, I place my cursor in a "good" area of the image and Option(Mac)/Alt(Win)-click, then release the key, move the cursor to the problem area, and click and hold as I paint over the imperfections.

To navigate through the image, I use the keyboard shortcuts Page Up and Page Down, which will move one full screen up or down. Adding the Cmd(Mac)/Ctrl(Win) key will move left or right one full screen. This ensures that I see every pixel of the document without unnecessary overlaps.

Several images that I really wanted to include in this book had reflections from the windows or lens flares from shooting into the sun. The methods I use to correct this type of problem depend on the complexity of the reflection. If the area is simple—a reflection in the sky, for example, I will remove it with the Healing brush, using the method described above.

If the reflection is over a detailed part of the image, I then use a more sophisticated technique involving dodging and burning. I'll begin by creating a new layer, filling it with 50% gray, and setting the layer's blend mode to Soft Light. The reason for adding this layer is flexibility—I don't want to work on the original image (in case I make a mistake), and I can't use the dodge and burn tools on a blank layer (thus the 50% gray fill). Changing the mode of the layer to Soft Light essentially hides the 50% gray fill.

Using the Burn tool set to midtones or highlights as needed, I select a brush the same size as the reflection. Working on the 50% gray layer and starting with very low opacity (3%), I darken the reflected area to match its surroundings. Where the values are uneven, I burn repeatedly, varying the brush size as necessary, slowly darkening the reflected area until it blends into its surroundings. If I need to lighten an area, I'll switch to the Dodge tool and repeat the process.

If I need to dramatically alter the tonal values, I will make a selection and then use an adjustment layer with a mask to blend the tonal values of the reflected areas with those elsewhere in the image that are correct (see details in the sections "Making Tonal Changes" and "Masking").

131

High-key image

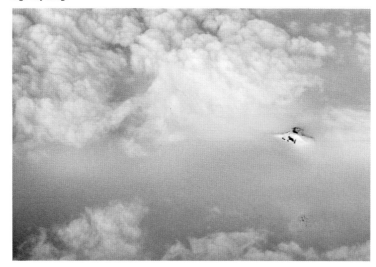

High-key histogram

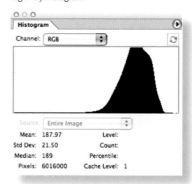

Average image

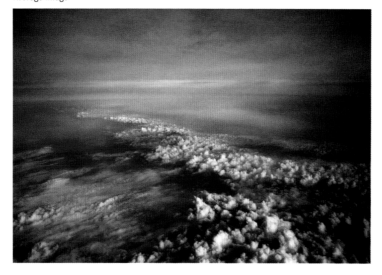

Average histogram

Low-key image

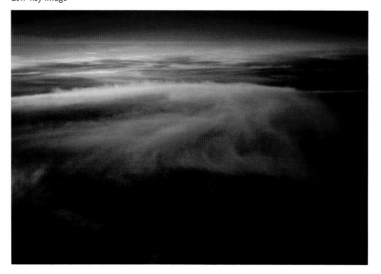

Low-key histogram

Making Tonal Changes

There are two different methods for applying adjustments to an image. Adjustments can be made directly to the image by using the Image → Adjustments menu, or they can be made with adjustment layers, using the Layer → New Adjustment Layer menu.

There are three primary benefits of using adjustment layers:

- Adjustment layers don't make permanent changes to the original image unless they are merged.

- Adjustment layers can be adjusted, readjusted, used in conjunction with each other, blended, added, or deleted at any time. Any of these techniques may be used as many times as needed without further degrading the original image.

- Adjustment layers can be applied to entire images to make global corrections or selectively for local adjustments. The visibility of their effects can be modified at any time.

The only real disadvantage of using adjustment layers is that they may increase file size and limit the number of file formats to which that file can be saved while retaining its adjustments in individual layers. Despite the impact on file size, I recommend using adjustment layers wherever possible to maintain flexibility as you work.

When making tonal changes to an image, I monitor the Histogram palette. It displays the tonal values in the image so that you can be sure you aren't clipping important highlights or shadow areas. I typically use a combination of Levels, Curves, and Color Balance to make all of my corrections.

Levels

Levels is an essential tool for managing the dynamic range of an image. In the Levels dialog, the histogram represents all of the pixel values in an image, plotted from 0 (black) on the left to 255 (white) on the right; the height of the column in the Input Level area shows how many pixels in the image have that value. You can view either the composite channels or each channel individually by using the Channels drop-down menu.

The histogram will vary from image to image. If you have a high-key image (white clouds, for example), most of the values in the histogram will fall on the right side. If you have a low-key image (such as the darkening sky at dusk), most of the columns in the histogram will fall on the left side. There is no such thing as a perfect histogram; each histogram will depend on the image. In histograms with large gaps, or "combing," each blank spot tells you that there is no information at that value in the image. Be careful of this, as it has the potential to lead to banding—large jumps from one tonal or color value to another—when you print the image.

One of the most common uses for the Levels dialog box is to maximize an image's dynamic range so it extends from black (0) to white (255). This can be extremely helpful when trying to add contrast to an otherwise flat image. Almost

Unrcorrected image

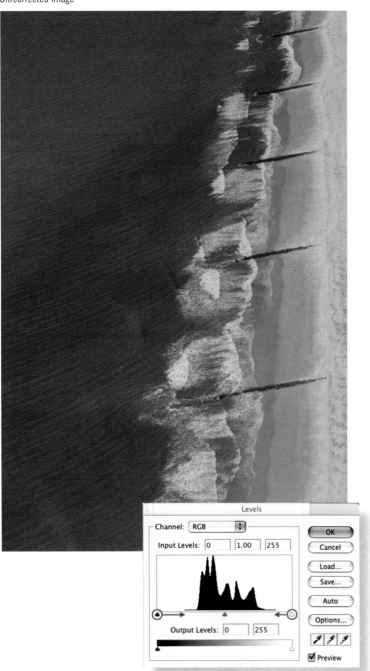

After correction with Levels adjustment layer

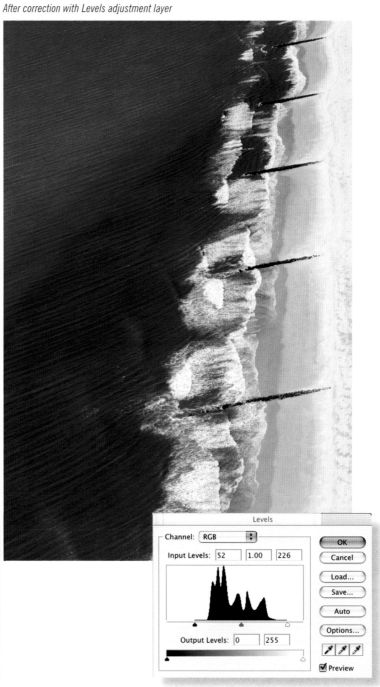

When the dynamic range of the image is improved, the colors tend to pop more.

all of the images for this project had extremely low dynamic ranges because I was shooting in very bright conditions with very few shadow areas through multiple layers of plastic.

If you photograph under controlled lighting conditions, you can adjust the lighting to capture an image that extends across the entire dynamic range and maintain detail in both the highlight and shadow areas. If this is the case, you may be able to skip this step. If you photograph in the middle of the day in bright sunlight, you may experience the opposite problem. It can be difficult (if not impossible) to capture the entire dynamic range of the scene with current digital and film technology. The highlights may be clipped to pure white or the shadows may be forced to pure black. In this situation, the goal is to keep detail in the highlights and hope that the shadow areas can be recovered.

For maximum flexibility, Levels should be applied as an adjustment layer rather than applying the adjustment directly to the image (as I mentioned in the introduction to this section). To maximize the dynamic range of an image, move the black triangle under the left side of the histogram until it reaches the first column of pixels. Depending on your image, it might already be there, in which case you don't have to do anything. Then move the white triangle under the right side of the histogram until it reaches the first column of pixels. Again, you may or may not have to do this, depending on your image.

A word of caution: if you see large spikes in the histogram at 0 or 255, you have large amounts of information in your image that are pure black or pure white. This means that the highlights are blown out (to pure white) or the shadows are pure black. In either case, it means that there is no detail in that part of the image in at least one, if not all, of the channels. Although this is sometimes unavoidable, you should try to capture images with a dynamic range within the camera's ability to record.

After applying a Levels adjustment, you may begin to see combing in the histogram palette. This can lead to banding (or gaps) in areas with subtle color variations due to stretching the dynamic range within the image. If you choose to work in 16-bit, the odds of creating banding are much lower because there is much more information representing each pixel.

The center slider is used to adjust the gamma, or midpoint, of the image. Dragging it to the right darkens the image; dragging to the left lightens it. However, there is only one gamma slider in the Levels dialog box, so many people prefer to use the Curves command. With Curves, you can use up to 16 different points to gain additional control over the image (see "Curves," later in this section).

If you're working with color images and are trying to remove a color cast, the Set Gray Point eyedropper can be a superb timesaver. If there is an object in the image that you know should be neutral (a grayscale balance card, gray clouds, or a gray cement wall), but has an apparent color cast, click with the Set Gray Point eyedropper in the area of the image that should be neutral gray. Photoshop will automatically adjust

the color clicked to gray. A word of caution, though: it is really rather subjective to select "clouds" or "cement" in your image as a definitive neutral tone. The clouds might have been captured at sunset, so they might have a lovely pink glow to them—or the cement might have turned yellow over time, or have a cyan cast due to shade. In this case, removing or correcting the color with the Set Gray Point eyedropper may give you undesirable results.

Sometimes you may want to set the black or white point or remove a color cast using the individual color channels. Just select a channel color (Red, Green, or Blue) from the Channel pull-down and adjust the sliders as necessary.

Set Gray Point eyedropper

When you use the Set Gray Point eyedropper, Photoshop will automatically neutralize the color you click on, which will result in a shift of the color balance of the entire image.

Uncorrected image

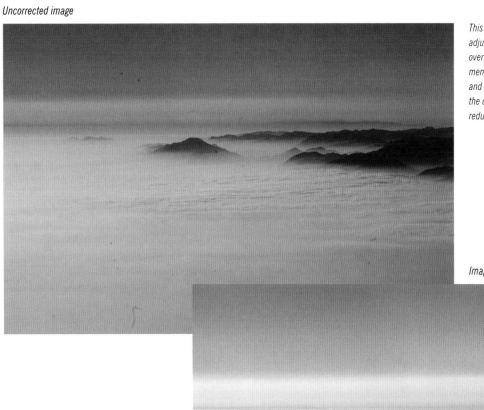

This image benefitted from both composite and component adjustments. The composite adjustment improved the overall tonal range of the image; the composite adjustments—slight adjustments to the Red and Green channels, and a significant adjustment to the Blue channel—changed the color balance to enhance the blue tones in the image, reducing the amount of yellow.

Image after component Curves adjustment

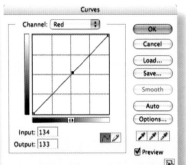

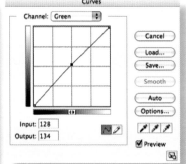

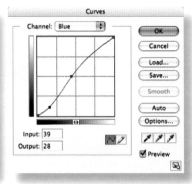

Uncorrected image

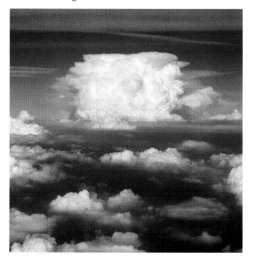

Image after composite Curves adjustment

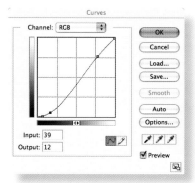

Curves

The most precise method for managing mid-range tonal and color values in an image is using Curves. The Curves dialog displays the shadows in the lower left, moving up diagonally through the midtones to the highlights in the upper right. (Note: this is the default display for RGB images. Grayscale and CMYK images are reversed so that the highlights are in the lower left and shadows are in the upper right.) By placing points on the curve, you can brighten or darken corresponding areas in the image. A total of 16 points can be placed on the curve for lightening or darkening values. Changes in values are displayed numerically in the lower left of the dialog. When changing tonal values, remember that if you're adding contrast to one area (increasing the slope of the curve), you are decreasing the slope of the curve in other areas. The "flattened" areas of the curve can appear flat (low in contrast) in the image. One way to avoid this is by creating selective adjustments (see "Selective Adjustments" below).

In Curves, you can choose to either work with the composite channel or with individual color channels using the Channels drop-down menu at the top of the dialog. To adjust tonal values, use the composite; to adjust specific colors, use the individual channels. To see where a specific tonal value falls on the curve, click and drag the cursor in the image area. A circle will appear on the curve at that value. Cmd (Mac)/Ctrl (Win)-click in the image area to set a point on the curve. For more precision, Opt (Mac)/Alt (Win)-click in the grid area to create additional grid lines.

Just as in Levels, you can also use the Set Gray Point eyedropper in Curves to eliminate a color cast. In fact, you can also move the end points of the curve in toward the center to redefine your black and white points if you prefer to make both moves in one dialog box.

Color Balance

While individual channels can be used to remove a color cast from an image, it's not exactly the most intuitive way for most people to correct color. A much friendlier way is to use a Color Balance adjustment layer. Simply drag the sliders toward the color to be added or away from the color to be subtracted. Notice that shadows, midtones, and highlights can all be targeted independently.

While Color Balance is more intuitive, the Curves command allows you to make more accurate adjustments on a per-channel basis, using multiple points.

Sometimes it's just easier to simply remove the offensive color from an image without trying to neutralize it using the opposite color. To desaturate a color, I often use a Hue/Saturation adjustment layer. I can choose to edit the master (all of the colors of the image at one time) or focus in on specific color ranges, using a combination of the pull-down menu and the gradient ramp.

137

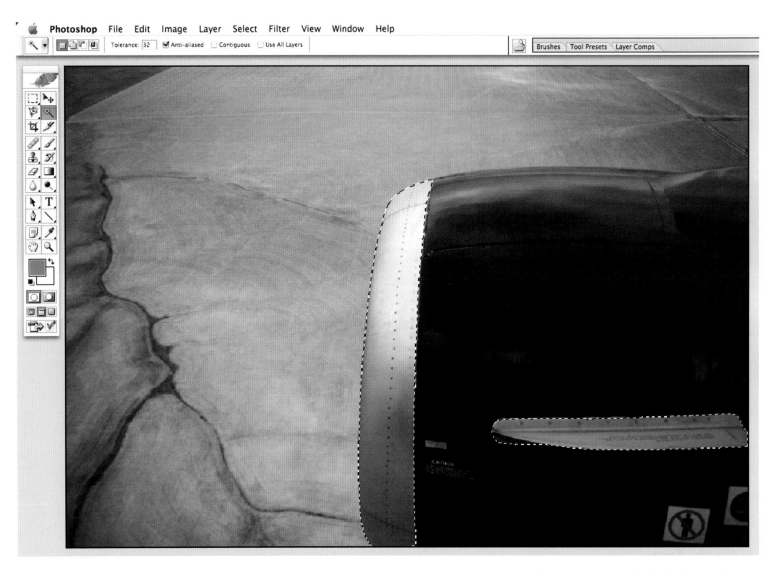

In this example, I used a combination of tools to select the gray metal on the jet engine: the Magic Wand for the basic selection and the Lasso tool to refine it.

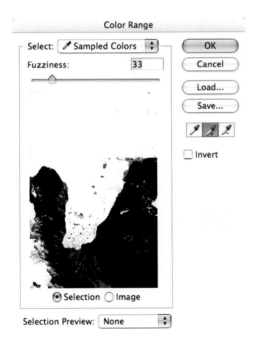

For this image, I used Color Range to select the water, then added an adjustment layer to remove some yellow in that area.

Color Range

Like the Magic Wand, Color Range (under the Select menu) selects pixels based on color. You can specify a predetermined range (such as reds or yellows) or use the eyedroppers to sample colors in the image. The Fuzziness slider adjusts the tolerance level; higher values capture a wider range of colors. Color Range also offers one the ability to select highlight, midtone, or shadow areas in the image.

Selective Adjustments

When making adjustments to isolated areas in an image, people tend to make them in one of two ways:

- Make a selection and then add the adjustment layer.

- Add the adjustment layer to the entire image and then paint the adjustment layer mask to hide and reveal the adjustment in areas as needed.

Both methods yield similar results, so it's really just a matter of personal choice which technique you use. If you choose to make the selection first, you can use any of the selection tools by themselves or in combination with others and/or with the Select menu.

The Marquee tools are the most basic and can be quite useful. Holding down the shift key while dragging with the marquee tools constrains the selection to a perfect square or circle. Holding down the spacebar while clicking and holding the mouse button lets you reposition the point of origin while you're dragging the selection; let go of the spacebar to continue making the selection. You can add to, subtract from, and find the intersection of multiple selections with these (and other) tools using the icons in the Options bar.

The Lasso tools allow for free-form, hand-drawn selections, as well as those made by drawing straight lines between mouse clicks. The Magic Wand makes selections based on color and is controlled with the Tolerance option in the Options bar.

For more complex selections, you may find it's best to use the Pen tool, which offers vector and free-form options (including Bezier curves), which may be saved and then edited point by point. First, select the Pen tool and create a Work Path around the area you want to select. You can then add or subtract points along the path and move them around to make the path amazingly accurate. When you're happy with the path, save it (Save Path in the Paths palette pull-down menu), especially if it is extremely detailed, as you may decide you want to edit or use it again later. To create a selection from a path, choose Make Selection from the Paths pull-down menu to convert it into an active selection. Photoshop allows you to define edge parameters, including the amount of feathering along the edges of the selected area and whether anti-aliasing is on or off. When working with multiple paths and selections you have the option to turn the path into a new selection or add it to, subtract it from, or intersect it with any existing selections.

Once you have created a selection, use Edit → Transform or the Select menus to modify the selection boundary: make it larger or smaller, rotate, select similar colors, smooth, expand, and/or contract it. After a selection is transformed, its edges may need to be adjusted to blend in to the rest of the image. To soften the edge of a selection, choose Select → Feather and enter a pixel value. The higher the value, the softer the edge. If an edge needs to be modified unevenly (soft in one area, hard in another), use the Quick Mask mode or Layer masks (see

Uncorrected image

Final image

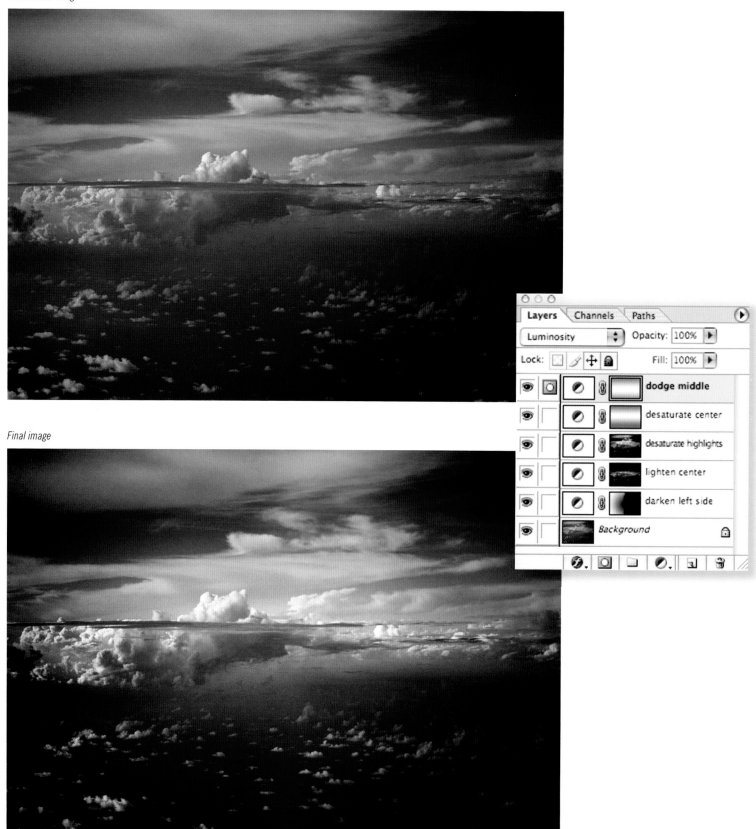

Uncorrected image

Final image

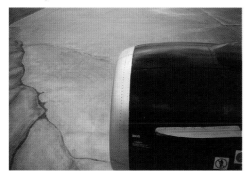

"Masking," in the next section) with the Brush tool to selectively soften the edges as needed.

Once you have a selection around the areas that need to be modified, add the desired adjustment layer. Photoshop creates a layer mask from the selection, automatically isolating the adjustment to the previously selected (now masked) area. If you need to make changes to the selection, simply modify the mask (see "Masking," below). If you prefer to add the adjustment layer first, you can use masking techniques to hide and reveal the effects of the adjustment without initially making a selection.

Masking

In Photoshop, layer masks work the same regardless of the type of layer to which they're applied. Where a layer mask is white, you can see the content or effect of the layer; where a layer mask is black, the layer's content or effect is hidden.

Painting varying levels of gray on a mask will result in varying degrees of opacity of (or effect applied to) the layer below. The gradient tool can be used to create subtle transitions in layer masks: where the gradient is white, the content or effect is visible (unmasked); as the gradient becomes darker, the content or effect gradually becomes more and more hidden from view. There is a great variety of gradient styles from which to choose, including linear and radial gradients—and different styles can create significantly different effects. In addition, varying the tonality of the foreground and background grays in the gradients can dramatically affect the mask.

If you add an adjustment layer to an image without first making a selection and then need to remove the effect from portions of the image, paint with black on the adjustment layer's layer mask. Paint with white to reveal the adjustment if you inadvertently hide too much. Using a large, soft brush at low opacity on an adjustment layer's layer mask can help you achieve subtle dodging and burning effects by selectively hiding and revealing the effects of the adjustment layer.

To refine an adjustment, double-click the adjustment layer in the Layers palette. This displays the adjustment's dialog with its settings. Remember, you can adjust and readjust those settings as many times as you like without permanently affecting the original image because you're working on an adjustment layer, not on the actual image itself.

You can also use layer opacity and blend mode settings to change the way that the content or effect of one layer is applied to the layers below. For example, if you add a Curves adjustment layer to an image and want only the tonal values (not the colors) to change, apply the adjustment layer and set its blend mode to Luminosity. This prevents any color shifts in the image.

You can use the Layers palette to select, view, and disable layer masks. In the Layers palette, select a layer mask by clicking on its thumbnail. To view a mask, Opt (Mac)/Alt (Win)-click on the mask icon. To display the composite image again, click on the eye icon. To temporarily disable a mask, shift-click on the mask icon.

Uncorrected image

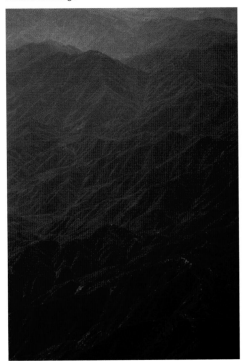

Neutral image

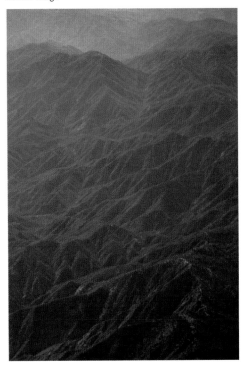

Image with one gradient fill applied

Final image

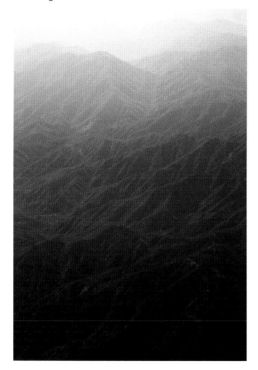

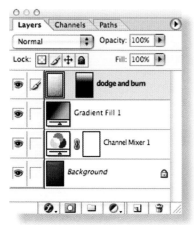

Adding False Color

When I want to recreate the original colors I observed from the plane or change the mood of an image, merely adjusting the existing colors in the image isn't always enough—sometimes I have to resort to more drastic measures.

I often want to start with a neutral image—a kind of "blank canvas," in terms of color. Instead of simply desaturating the image or using Photoshop's default color mode conversion, I use a Channel Mixer adjustment layer for maximum control and flexibility. This allows me to use my own unique combination of the original image's red, green, and blue channels to simultaneously eliminate the color and create a custom "grayscale" image. (Note: in the Channel Mixer dialog, check the Monochrome option to achieve a grayscale appearance.)

Once I've created a neutral image, I add false color using a Gradient Fill adjustment layer. I can create anything from a simple, two-color, linear gradient to a complex, radial kaleidoscope of colors. Choosing Layer → New Fill Layer → Gradient allows me to select a blend mode in the New Layer dialog box. I have found the Color, Multiply, Overlay, and Soft Light blend modes to be particularly useful, but it depends on the image as well as the colors you choose, so don't hesitate to experiment. (Note: If you don't select a blend mode, the colors will obscure the image in the layers below.)

In the Gradient Fill dialog, clicking on the gradient displays the Gradient Editor, where I can make and save custom gradients. After creating a gradient, I can use the Gradient Fill dialog to choose additional options such as Style, Angle, and Scale. Once I've applied the gradient fill, I may try different blend modes as well as decreasing the layer opacity for a more subtle effect. Occasionally I use multiple gradients overlapping and blending at varying angles to create the effect I want.

143

The Gradient Fill Dialog

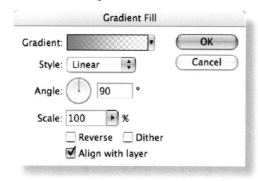

Filename: DSC9664.NEF (original camera capture)

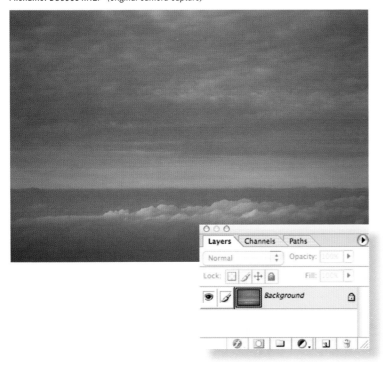

Filename: ORD_DFW_2002L.psd (retouched, layered image)

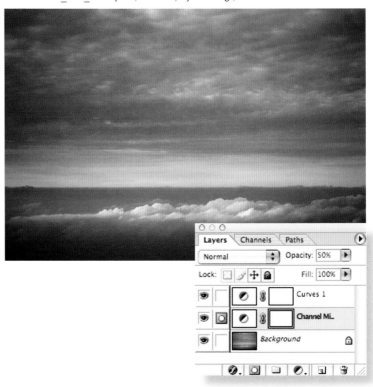

Filename: ORD_DFW_2002L01.psd (another version of retouched, layered image)

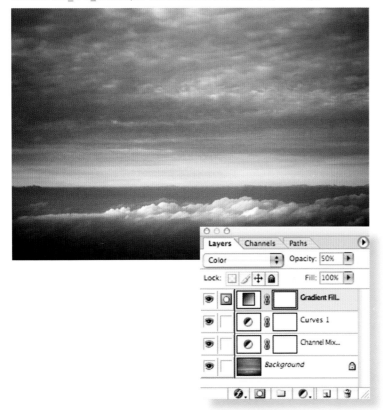

Filename: ORD_DFW_2002FSPL.psd (sharpened, flattened image, set for Premium Luster

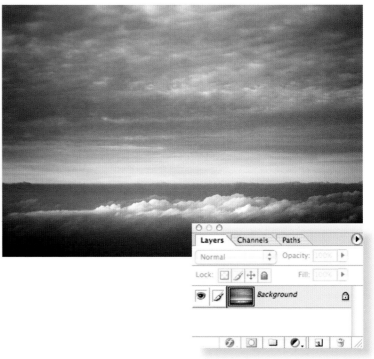

Saving Files

Once I've finished all of my image editing, I save the retouched image as a .PSD file, which ensures that all layers, masks, ICC color profiles, and channels are retained. I also set Photoshop's File Handling preference, Maximize PSD and PSB File Compatibility, to Always, which enables me to use the images faster and more easily with other applications, including Bridge, even though this preference may increase file size. It also will allow me to open a flattened version of the file if I ever need to in the future.

To keep image management to a minimum, I rename the image using a simple naming convention: I add an "L" to the name to indicate that the image contains multiple layers. I also know it has been modified because it's a .PSD (Photoshop) file, not a .TIF (from my scanner) or a .NEF (from my digital camera). If I need to make additional modifications to the file at a later date and don't want to save over the previous file, I begin sequencing the files by adding "01", then "02", etc., to the end of the file name. Although this might seem mundane, it's far better than ending up with three copies of an image named CloudBest.psd, CloudDone.psd, CloudFinal.psd. I would never remember which one was which and would waste time opening them all to see which one was really the final, finished file.

There are a variety of file formats to which you can save, but not all of them support the extensive features in Photoshop CS or CS2. Files that have multiple layers should be saved as .PSD, .PDF, or .TIF files. Other file formats such as .BMP or .JPEG will flatten the file, eliminating layers and the ability to modify them at a later date. By

looking at the save options in the Save As dialog, you can see whether features such as multiple layers and ICC profiles will be saved with the document when you select a specific format.

If size is a concern—for example, you need to email someone an image—you can save the file as a JPEG, but keep in mind that the JPEG file format uses lossy compression, so not only will all layers be merged together, but thousands of colors will be discarded. Depending on the compression options, the loss in quality can range from mild to severe and is directly related to the resulting file size—the larger the file, the better the quality, and vice versa. With this in mind, make sure that you retain your layered file, and save a copy as a JPEG. If your image is opened from a format other than JPEG, you won't have to worry about writing over the original file, but if your image started off as a JPEG, be sure you've changed the name of the file so that you don't accidentally save over the original.

Sometimes, security can be a concern for an image. Perhaps you are working on photographs of prototypes and need to send them via email to your client, while making sure that even if someone else inadvertently received the files, they wouldn't be able to view them. Saving the images as Photoshop PDF files and using the security options to set passwords for image viewing and modifications will limit who can open the files and what that person can do with them.

After saving, I archive all of my edited images to DVD and also copy them to an external hard drive. I put the DVDs into storage in a second location; the external hard drive allows me to keep all of my images "online" and available when I'm working, so I don't have to waste time looking for them on multiple CDs or DVDs.

When I create a CD or DVD, I use the contact sheet feature in Photoshop to quickly generate and print a visual reference of all of the images on the media.

PDF Security settings are accessed by saving your file using Save As and selecting Photoshop PDF as the format. In the Save Adobe PDF dialog that opens, click on the Security box to open this dialog and select the settings you want.

RGB image (simulated) *CMYK image (actual)*

For output to an inkjet printer, RGB files are preferred, but if you're going to be sending your files to a commercial printer for process-color printing, your files will need to be converted to CMYK. Due to the multiple variables involved in offset printing (resolution, dot gain, paper, inks, type of press, etc.), consult with your printer before converting your files to CMYK. If the color is absolutely critical, you may want to hire an expert to do the conversions for you and supply you with color proofs before the job is printed. In any case, convert the images after you've done all of your color correction and retouching. Save the flattened CMYK file either a .tif or .eps format—and be sure to include "cmyk" in the filename, so you'll know which file is which.

When your files are converted to CMYK, you'll notice that the colors may shift slightly. That is to compensate for the more limited range of colors (called the "gamut") that can actually be reproduced on press. In the example shown above, you can see that the histograms of the two versions of the image are significantly different.

Proof Setup for offset printing

To view a "soft proof" of the CMYK image on-screen in the Proof Setup dialog, be sure to set the Profile to match the final printing process the offset printer will use. There are a number of options to choose from to replicate what the image will look like when printed sheet-fed versus web offset on coated or uncoated paper. Consult with the printer so that you know what those settings should be to give you the most accurate representation of the actual printed results.

Preparing Images for Print

I do a few last things to prepare an image for print. If the image has multiple layers, I flatten it because working with a flattened image is faster (it's smaller and Photoshop doesn't need to think about how to display multiple layers). Then I make sure the image is the correct size. Because of the algorithms Photoshop uses for sizing images, I prefer Photoshop's Image Size command over the printer driver when resizing images. If the image needs just a slight adjustment, I'll use the Bicubic interpolation to resample the image. If it needs to be resampled up dramatically, I use the Bicubic Smoother option; for resampling down, the Bicubic Sharper. If images need sharpening after resizing, I use either the Unsharp Mask or the Smart Sharpen filter. I can also perform selective sharpening by duplicating the image onto a second layer, sharpening that layer, and then using a layer mask to reveal or hide parts of the sharpened layer.

Photoshop's Soft Proof feature allows me to simulate on-screen what the image will look like on a given output device. I can choose to soft proof for a desktop printer (using the printer's profile) or a CMYK device. I can also preview what the image will look like as a result of choosing different rendering intents. Based on the proof, I can make any necessary changes to the image.

When I'm satisfied with the proof, I select Print with Preview, which allows me to place the image on the page as well as choose how to color-manage the image. For Color Handling, I select Let Photoshop Determine Colors, choose the printer profile, and select a preferred rendering intent for my printer.

Clicking Print exits Photoshop and enters the printer driver. If you have chosen to use Photoshop's color engine to convert your image to the color space of the printer (as we did above), make sure that you have turned off any other color management features in the printer driver, or you will convert the file twice, which I can almost guarantee will not look like the soft proof when printed. For best results, make sure that you designate other important information, such as paper types and inks, in the printer driver before printing.

If I think I'll want to print the image again, I save the flattened, resized, and sharpened file with a new name, again using a naming convention such as "FSPL" for Flattened, Sharpened, on Premium Luster paper, or "FSM" for Flattened, Sharpened, on Matte paper. I then archive these images onto DVDs and my external hard drive along with the layered versions.

147

Proof Setup for inkjet printing

To set up a proof, go to View → Proof Setup, and select Custom from the menu. There are a number of different profiles from which to choose, including specific inkjet printers (such as the Epson printer in the example to the right) and commercial offset processes. You can also set the soft proof to preview what the image will look like on different electronic displays if you are tweaking your files for display on a specific type of computer monitor or for video.

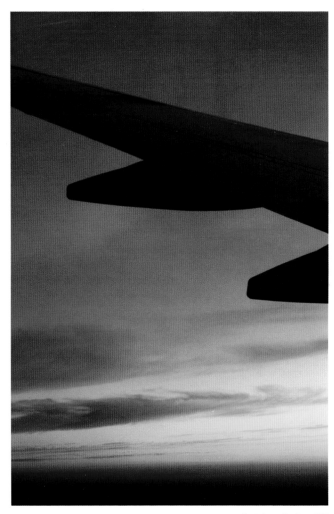

Santa Ana to San Jose, 2003